Masterpieces of

Fra Angelico

(1908)

ISBN-13 : 978-1512325485
ISBN-10 : 1512325481

Copyright©2012-2014 Iacob Adrian
All Rights Reserved.

Notice

This documentary study use historic, archived documents.

Because of this, some pages may look blurry or low quality.

Still are included in this book because they have

high value from critical, documentary, historical,

informative and journalistic point of view .

Dtp and visual art

Iacob Adrian

THE
MASTERPIECES
OF
FRA ANGELICO
(1387-1455)

Sixty reproductions of photographs from the original paintings, affording examples of the different characteristics of the Artist's work

Author statement

This is a series of art books.

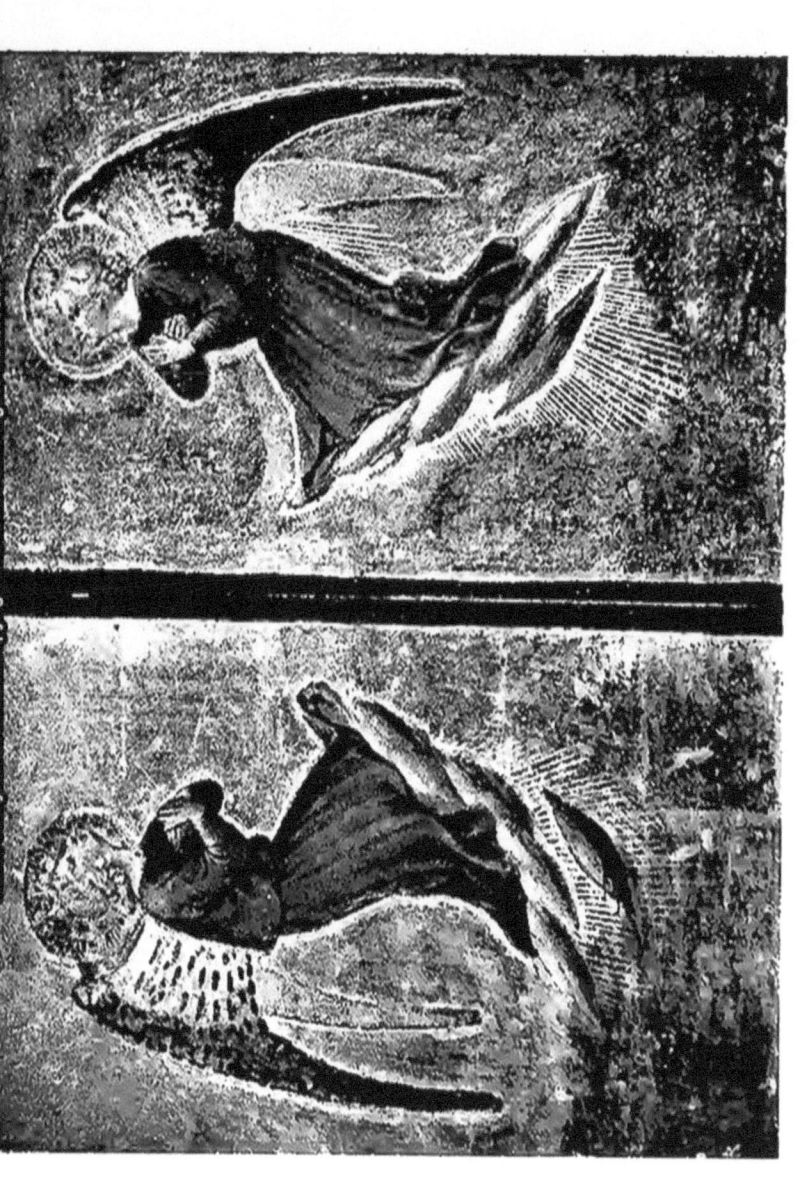

Two Angels
(*Pinacotheca, Turin*)

Zwei Engel
(*Turin, Pinakothek*)

Deux Anges
(*Pinacothèque, Turin*)

D. Anderson, Photo.

This little Book conveys the greetings of

..

to

..

———————————————

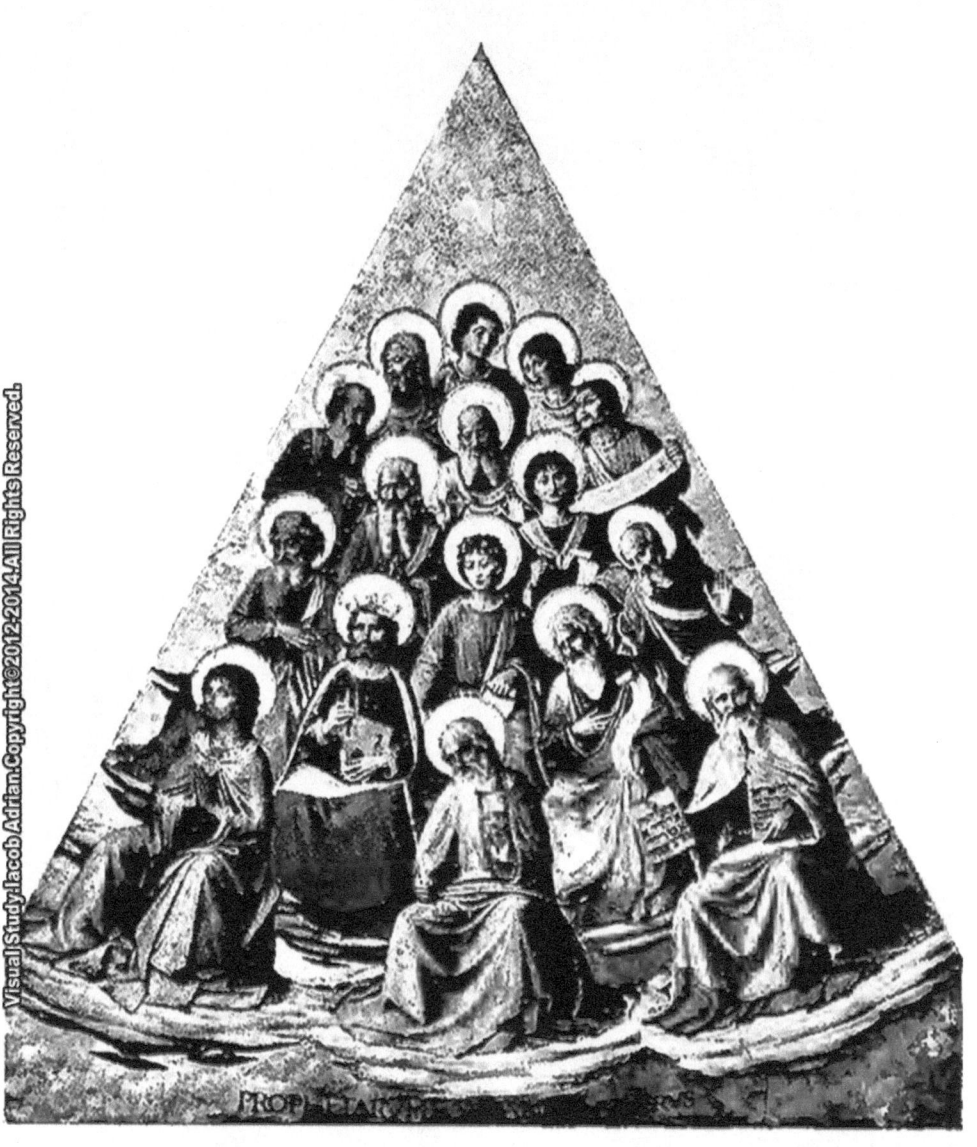

CHOIR OF PROPHETS
(FRESCO)
(Cathedral, Orvieto)

CHŒUR DE PROPHÈTES
(FRESQUE)
(Cathédrale, Orvieto)

PROPHETENCHOR (FRESKE)
(Orvieto, Dom) Frat. Alinari, Photo.

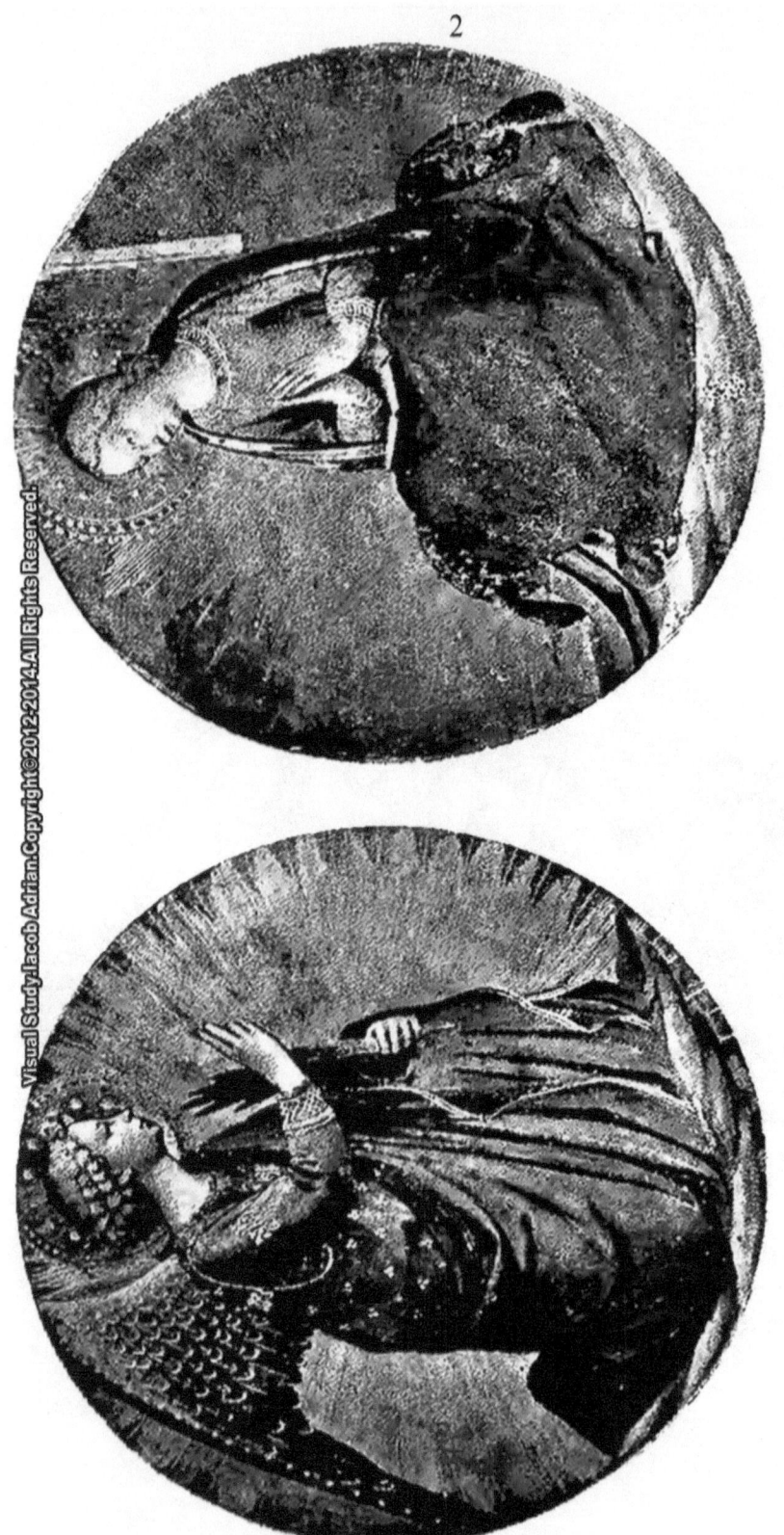

THE ANNUNCIATION
(*Pinacotheca, Perugia*)

DIE VERKÜNDIGUNG
(*Perugia, Pinakothek*)
Frat. Alinari, Photo.

L'ANNONCIATION
(*Pinacothèque, Pérouse*)

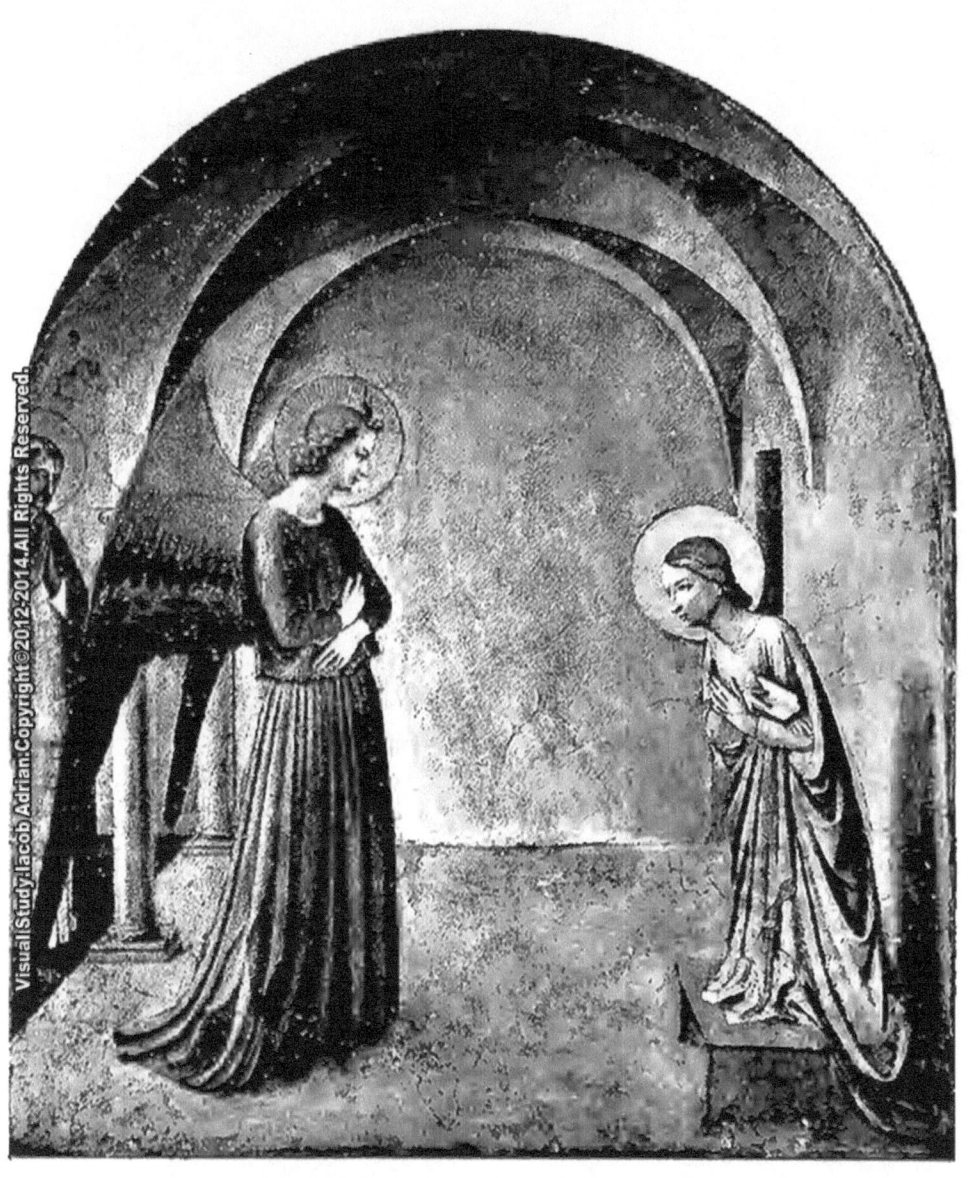

THE ANNUNCIATION (FRESCO) L'ANNONCIATION (FRESQUE)
(*St. Mark's, Florence*) (*Église St-Marc, Florence*)
DIE VERKÜNDIGUNG (FRESKE)
(*Florenz, Markuskirche*) *D. Anderson, Photo.*

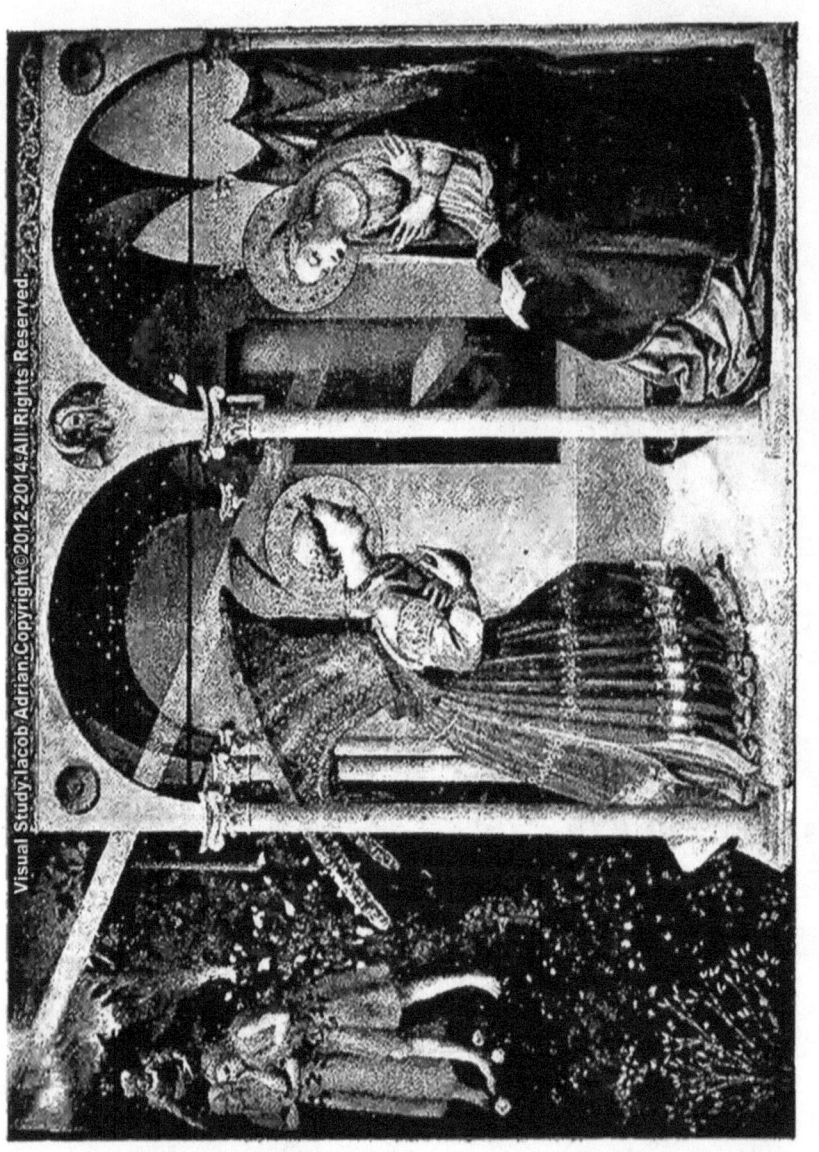

The Annunciation
(Prado, Madrid)

Die Verkündigung
(Madrid, Prado)

L'Annonciation
(Prado, Madrid)

F. Hanfstaengl, Photo.

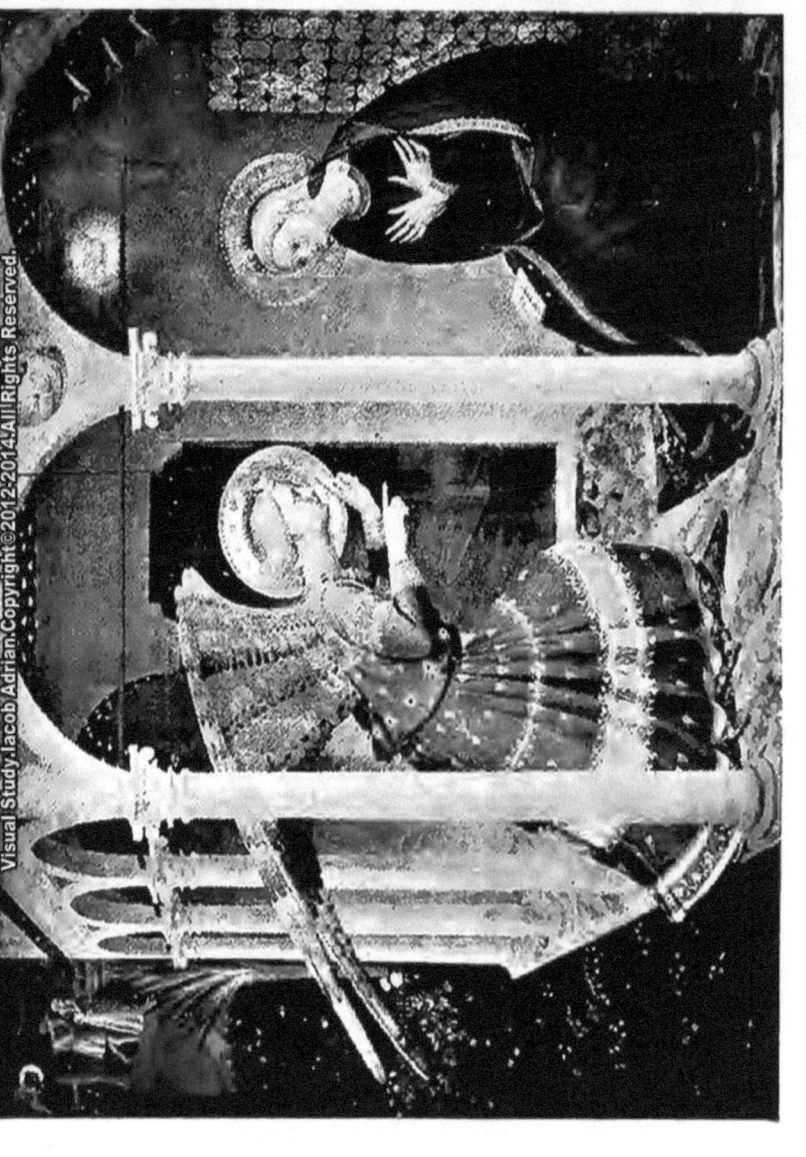

The Annunciation
(Church of Jesus, Cortona)
L'Annonciation
(Église de Jésus, Cortone)
Die Verkündigung
(Cortona, Jesuskirche)

Frat. Alinari, Photo.

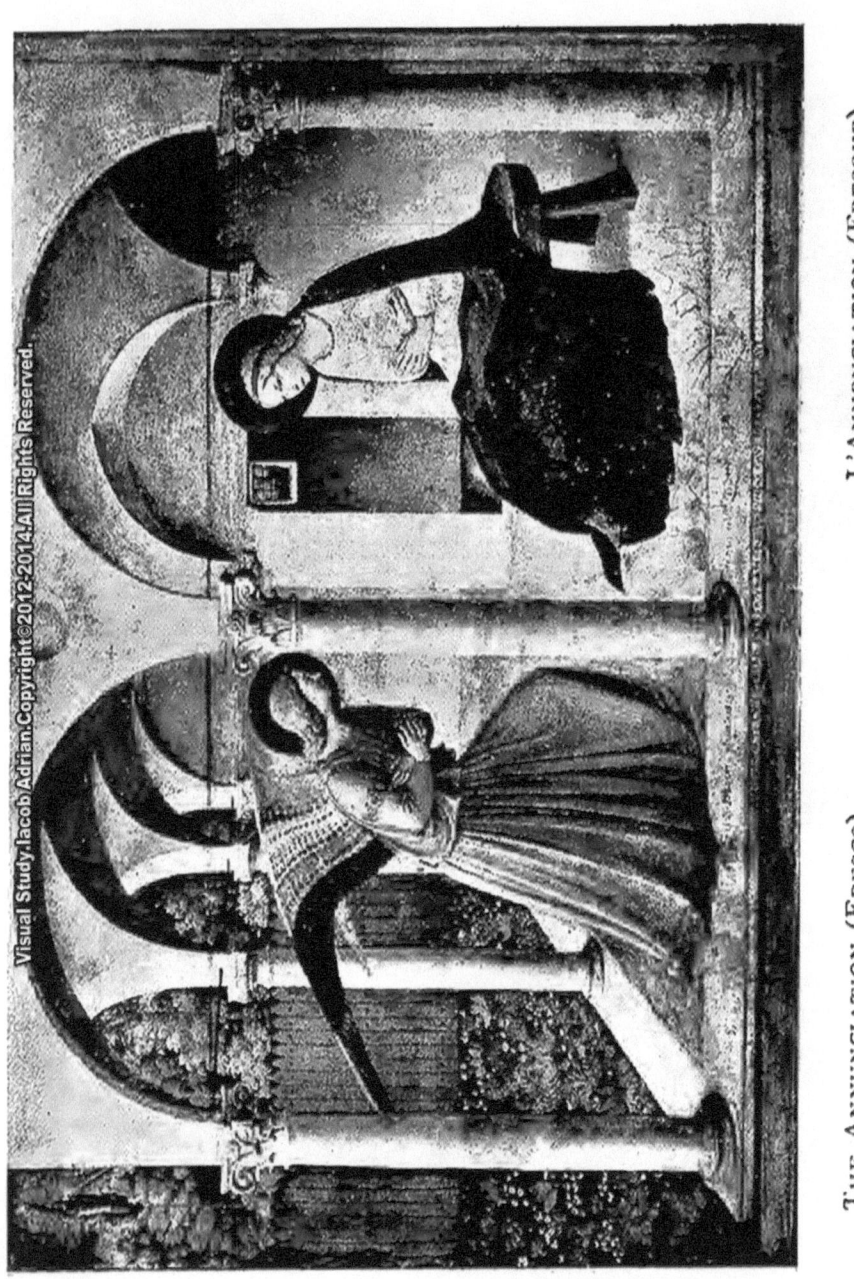

THE ANNUNCIATION (FRESCO)　　　　L'ANNONCIATION (FRESQUE)
(*St. Mark's, Florence*)　　　　　　(*Église St-Marc, Florence*)
DIE VERKÜNDIGUNG (FRESKE)
(*Florenz, Markuskirche*)
D. *Anderson, Photo.*

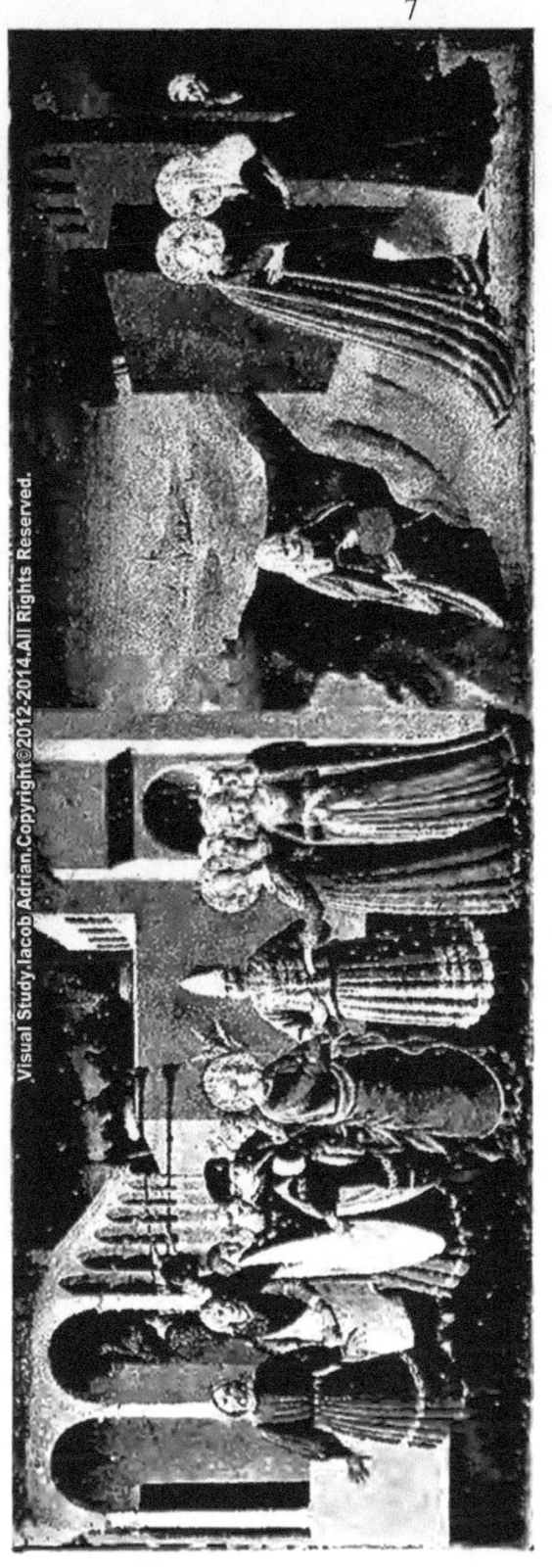

THE MARRIAGE OF THE VIRGIN AND THE [PREDELLA] LE MARIAGE DE LA VIERGE ET LA
VISITATION VISITATION
(Church of Jesus, Cortona) (Église de Jésus, Cortone)
MARIÄ VERMÄHLUNG UND DIE HEIMSUCHUNG
(Cortona, Jesuskirche) Frat. Alinari, Photo.

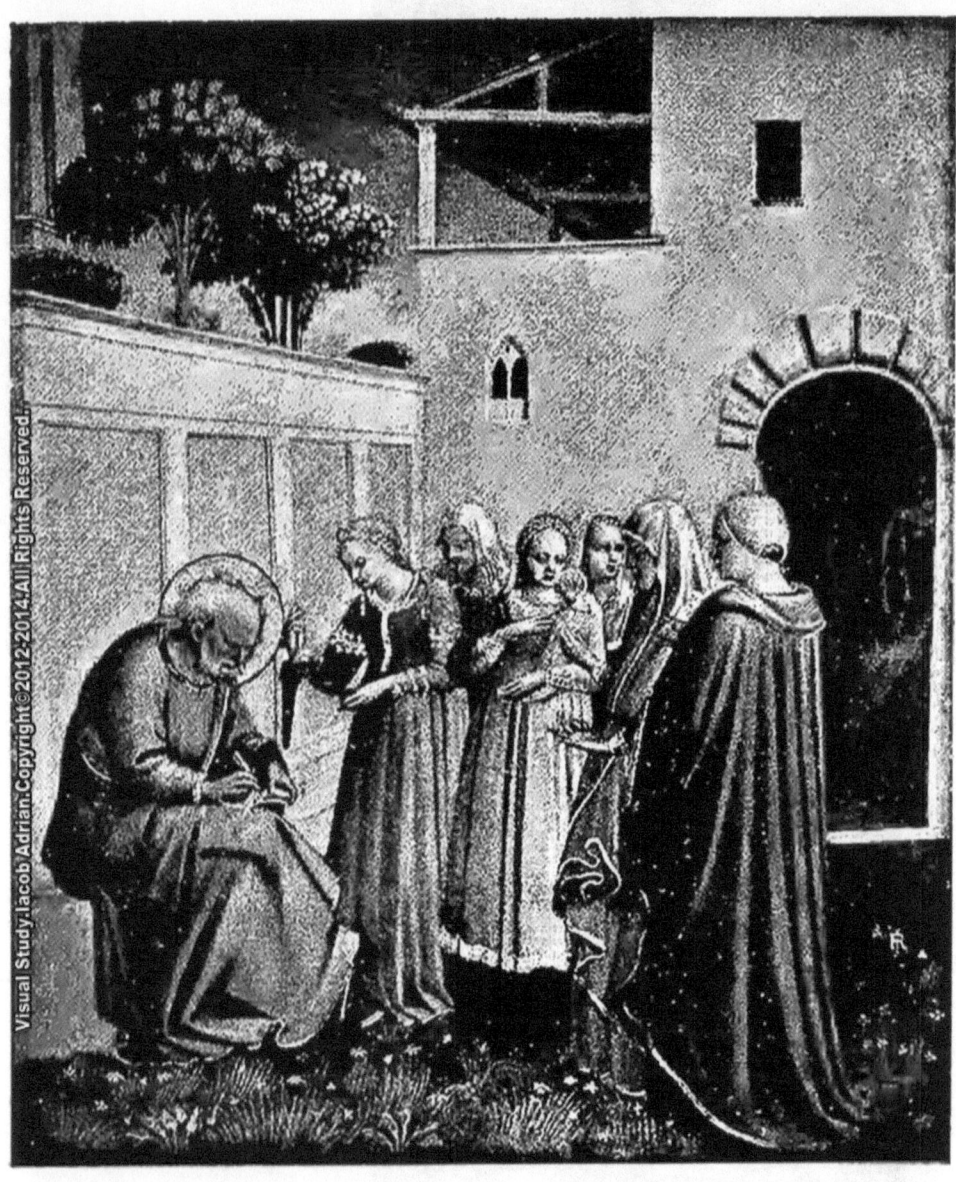

The Naming of St. John the Baptist
(*Uffizi, Florence*)

On nomme St Jean-Baptiste
(*Galerie des Offices, Florence*)

Man nennt Johannes den Täufer
(*Florenz, Uffizien*)

D. *Anderson, Photo.*

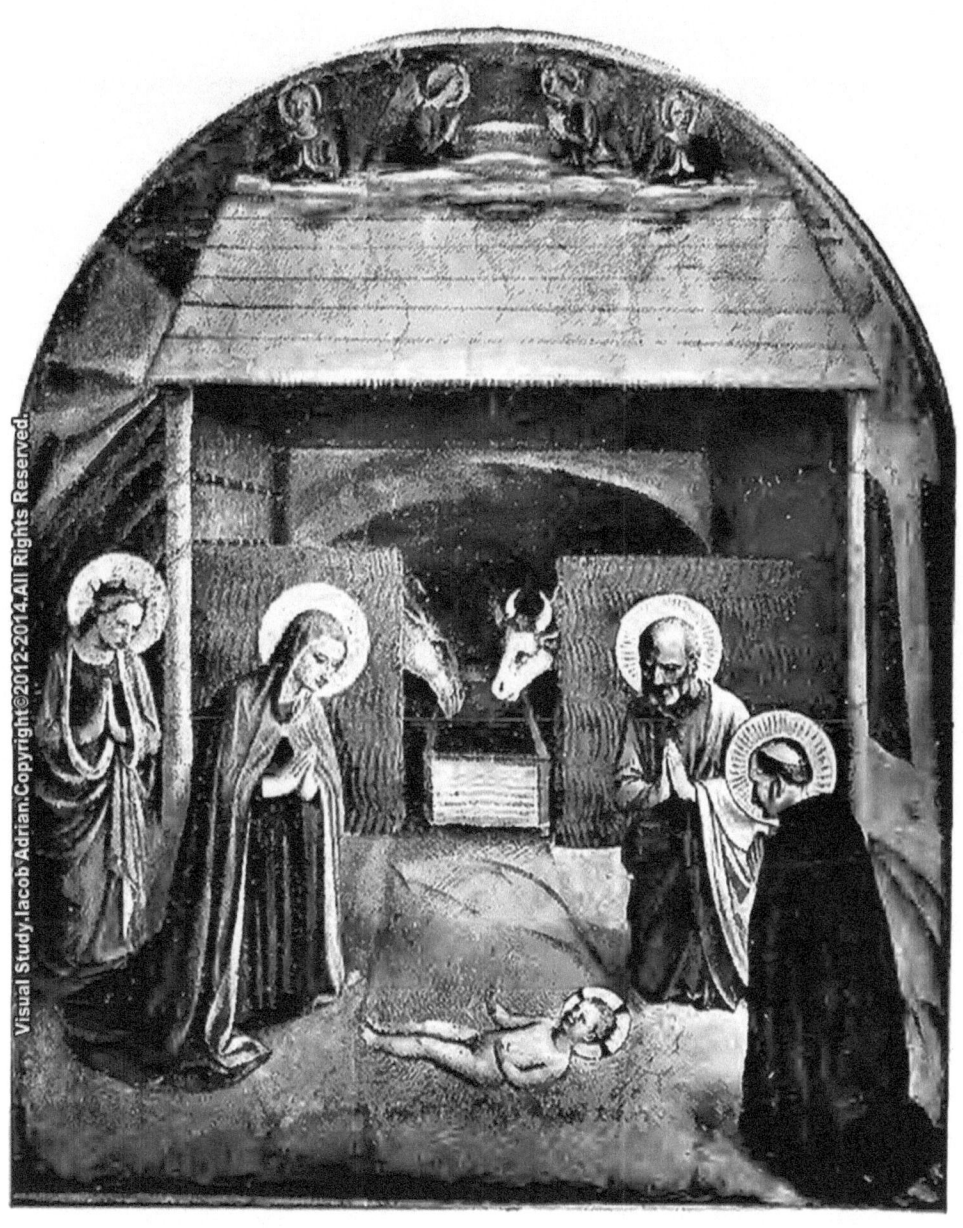

THE NATIVITY (FRESCO) LA NATIVITÉ (FRESQUE)
(St. Mark's, Florence) (Église St-Marc, Florence)
DIE GEBURT CHRISTI (FRESKE)
(Florenz, Markuskirche)
D. Anderson, Photo.

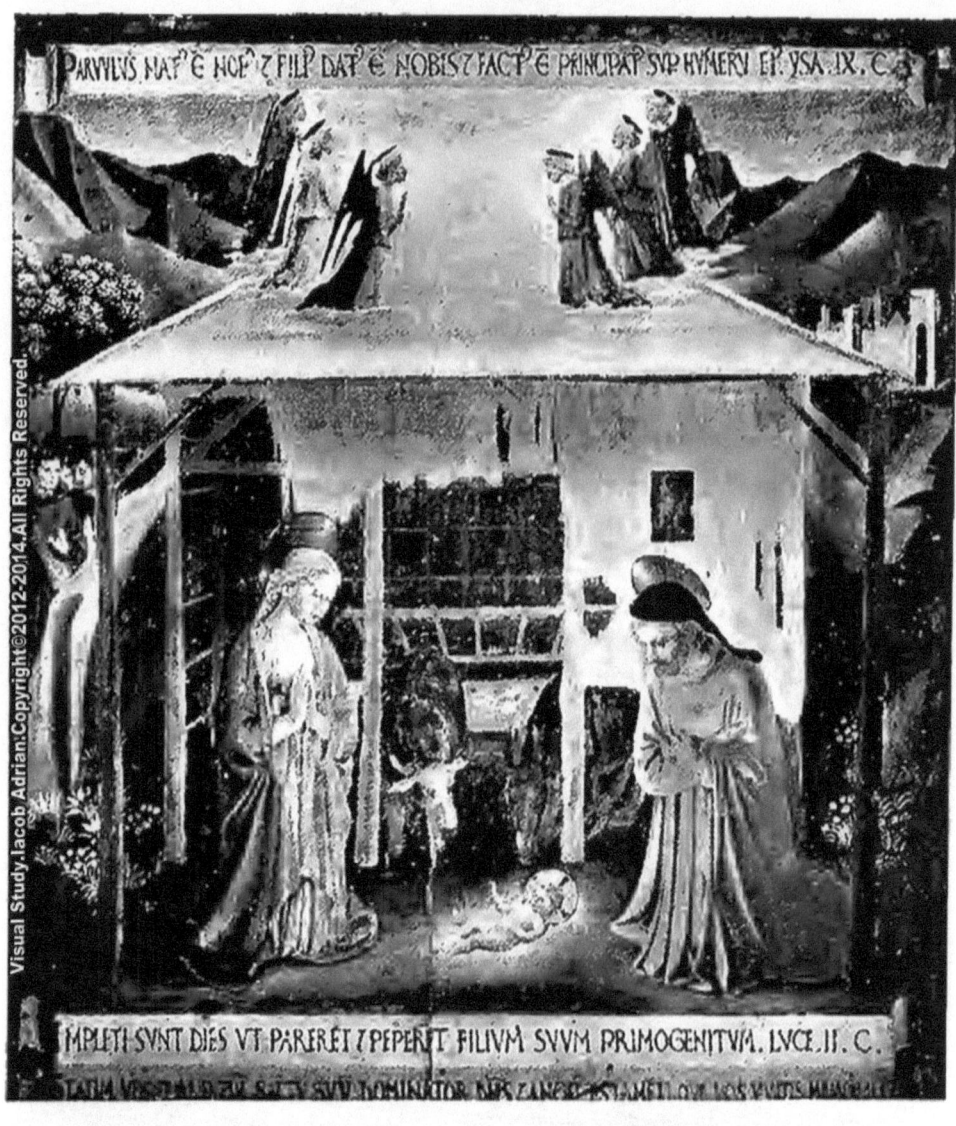

THE NATIVITY
(*Academy, Florence*)

LA NATIVITÉ
(*Académie, Florence*)

DIE GEBURT CHRISTI
(*Florenz, Akademie*)
D. *Anderson, Photo.*

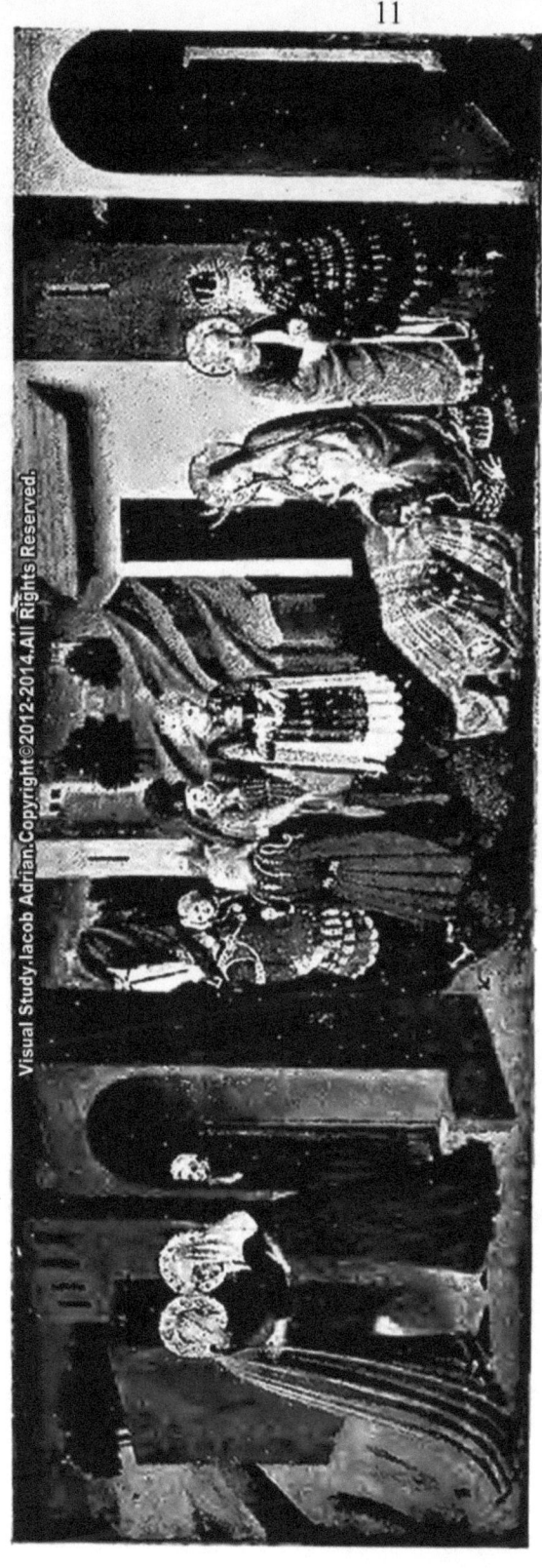

THE VISITATION AND ADORATION OF THE MAGI [PREDELLA] LA VISITATION ET L'ADORATION DES MAGES
(Church of Jesus, Cortona) (Église de Jésus, Cortone)
MARIÄ HEIMSUCHUNG UND DIE ANBETUNG DER WEISEN
(Cortona, Jesuskirche)

Frat. Alinari, Photo.

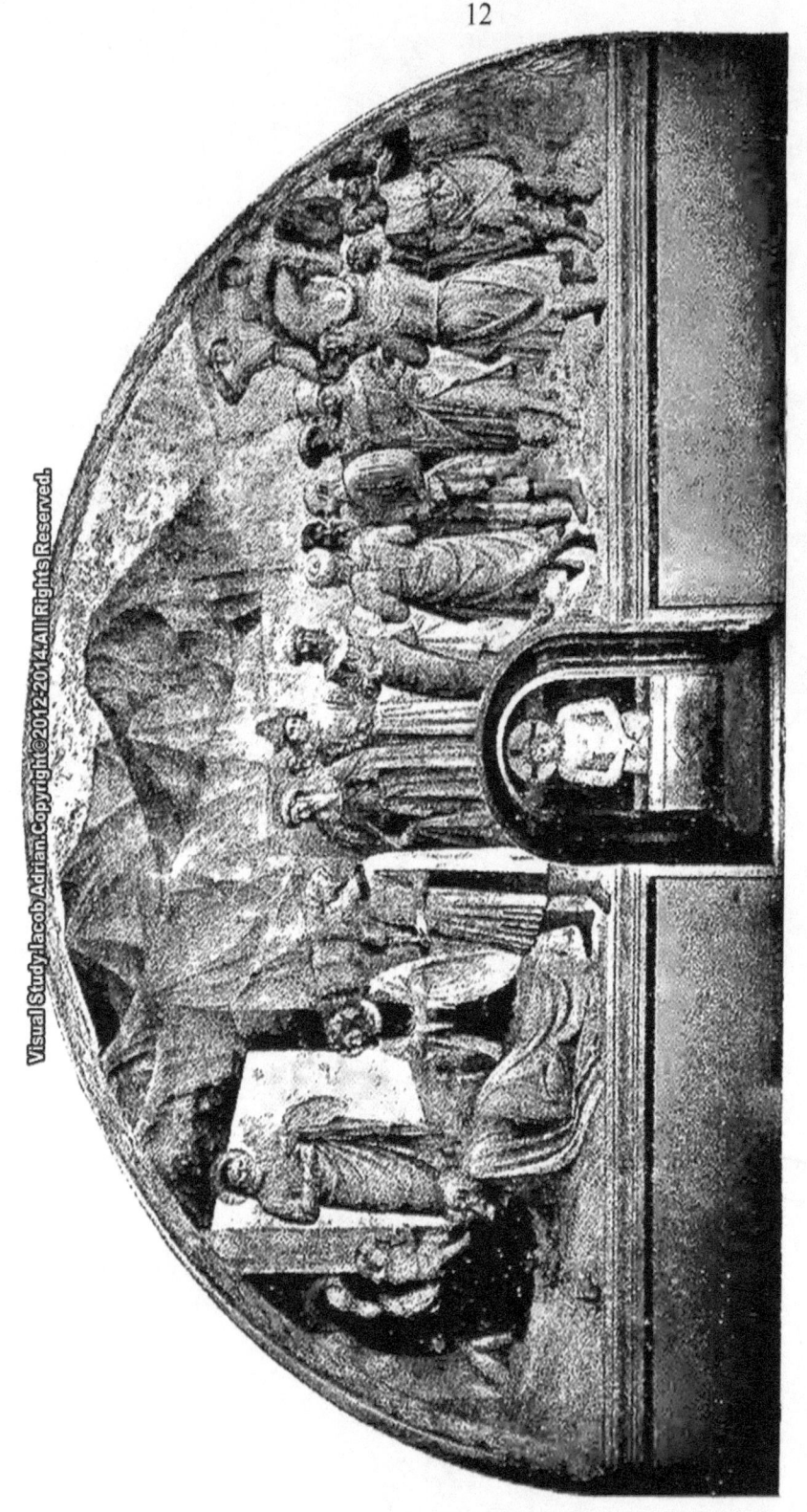

THE ADORATION OF THE MAGI (FRESCO) L'ADORATION DES MAGES (FRESQUE)
(*St. Mark's, Florence*) (*Église St-Marc, Florence*)
DIE ANBETUNG DER WEISEN (FRESKE)
(*Florenz. Markuskirche*)
D. *Anderson, Photo.*

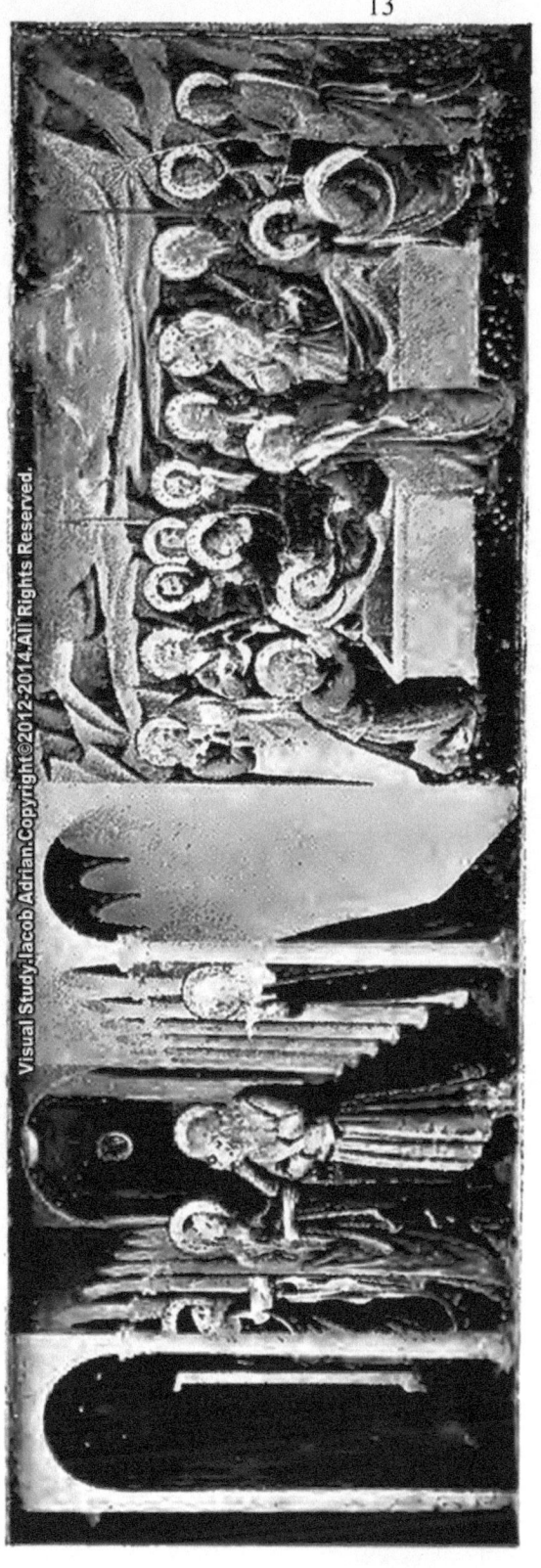

The Presentation in the Temple and Death of the Virgin [Predella] La Présentation au Temple et la Mort de la Vierge
(Church of Jesus, Cortona) (Église de Jésus, Cortone)

Mariä Reinigung und Tod
(Cortona, Jesuskirche)

Frat. Alinari, Photo.

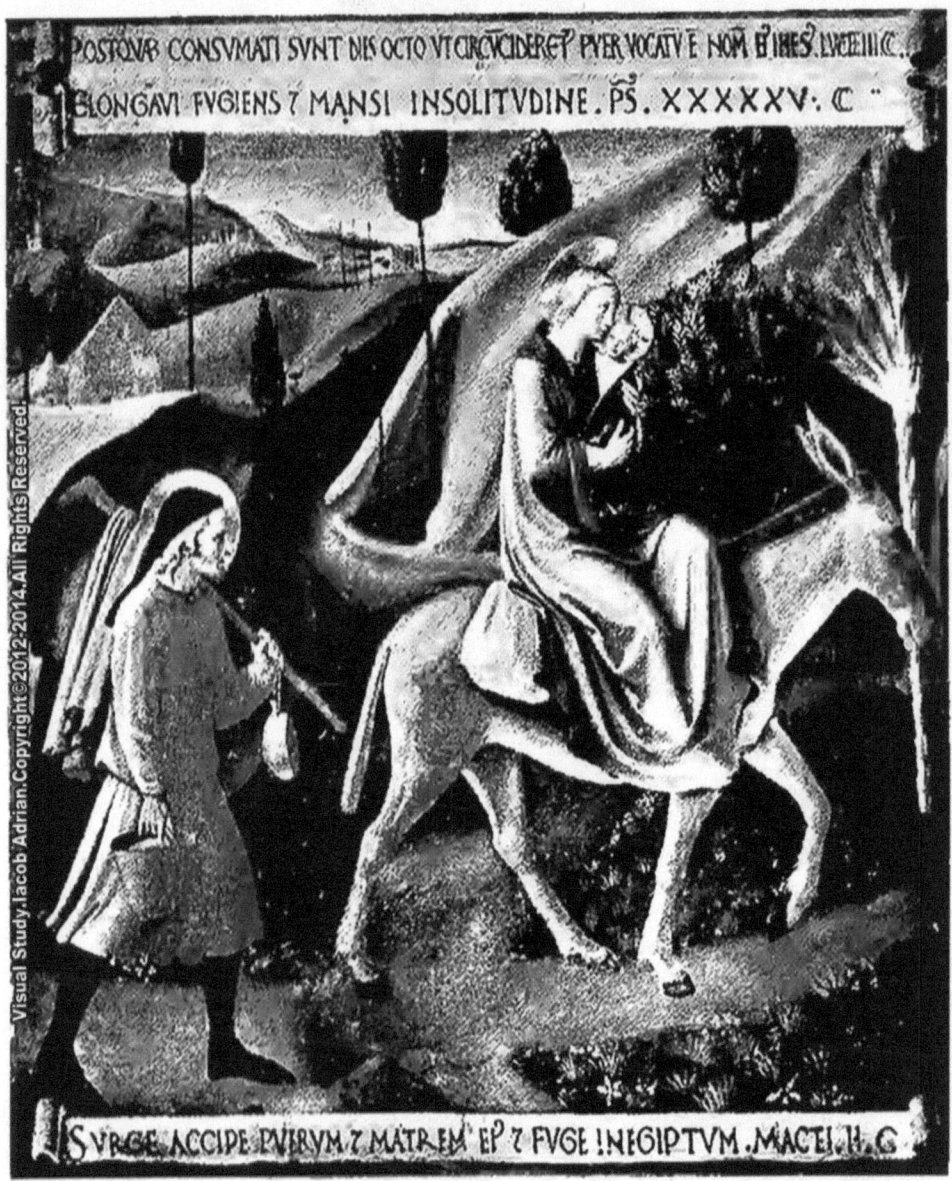

The Flight into Egypt
(Academy, Florence)

La Fuite en Égypte
(Académie, Florence)

Die Flucht nach Egypten
(Florenz. Akademie)
D. Anderson, Photo.

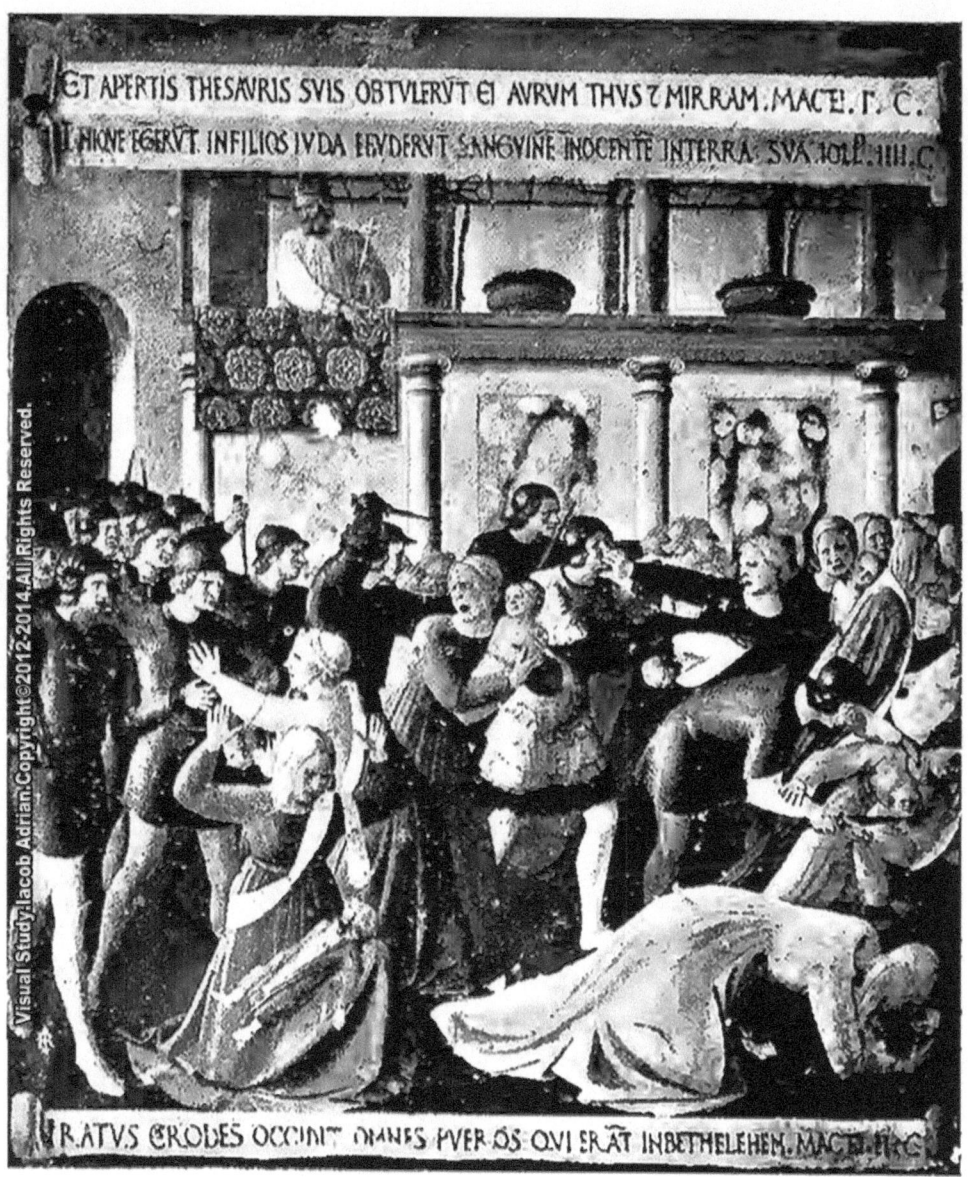

THE MASSACRE OF THE
INNOCENTS
(*Academy, Florence*)

LE MASSACRE DES
INNOCENTS
(*Académie, Florence*)

MORD DER UNSCHULDIGEN KINDLEIN
(*Florenz, Akademie*)
D. Anderson, Photo.

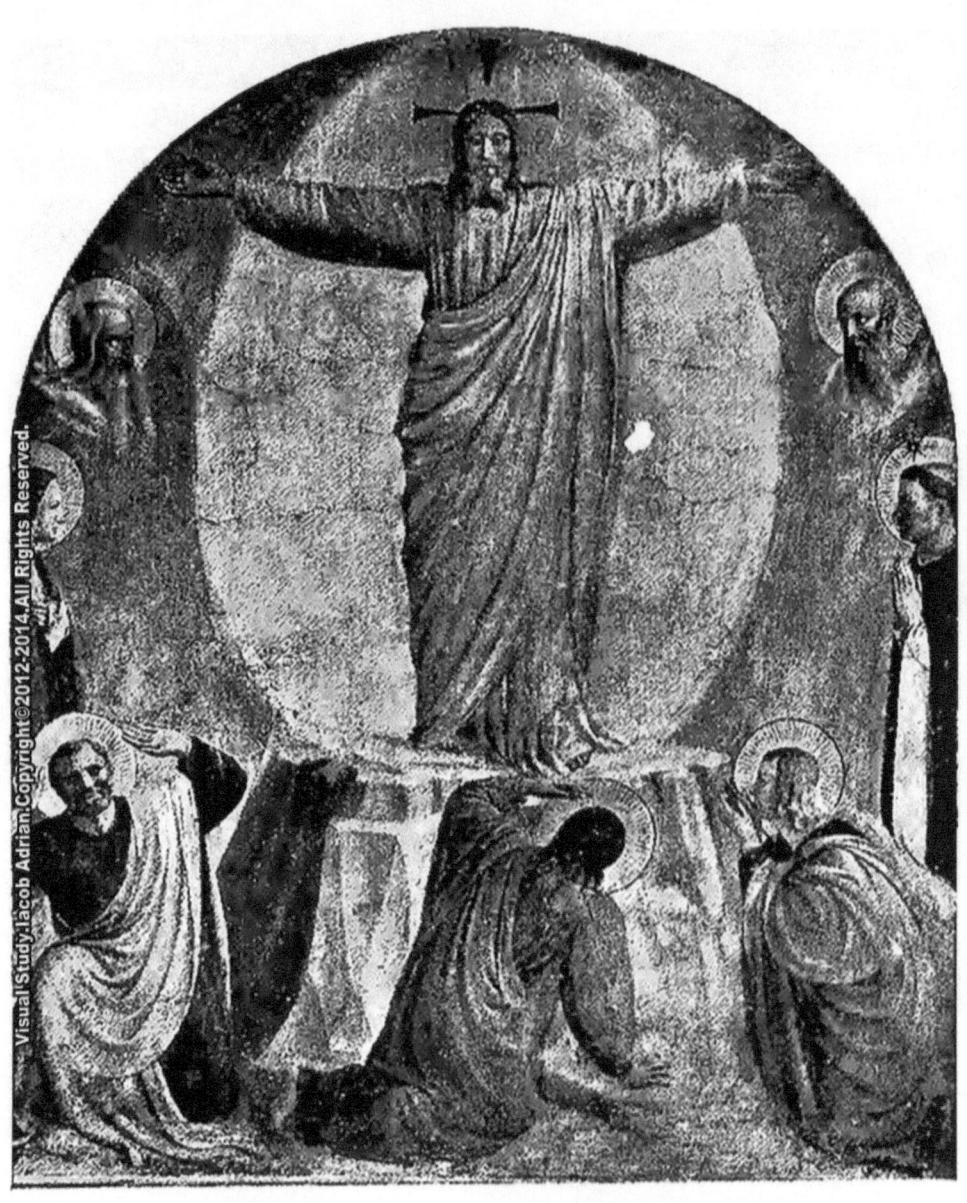

THE TRANSFIGURATION
(FRESCO)
(*St. Mark's, Florence*)

LA TRANSFIGURATION
(FRESQUE)
(*Église St-Marc, Florence*)

DIE VERKLÄRUNG CHRISTI (FRESKE)
(*Florenz, Markuskirche*)
D. Anderson, Photo.

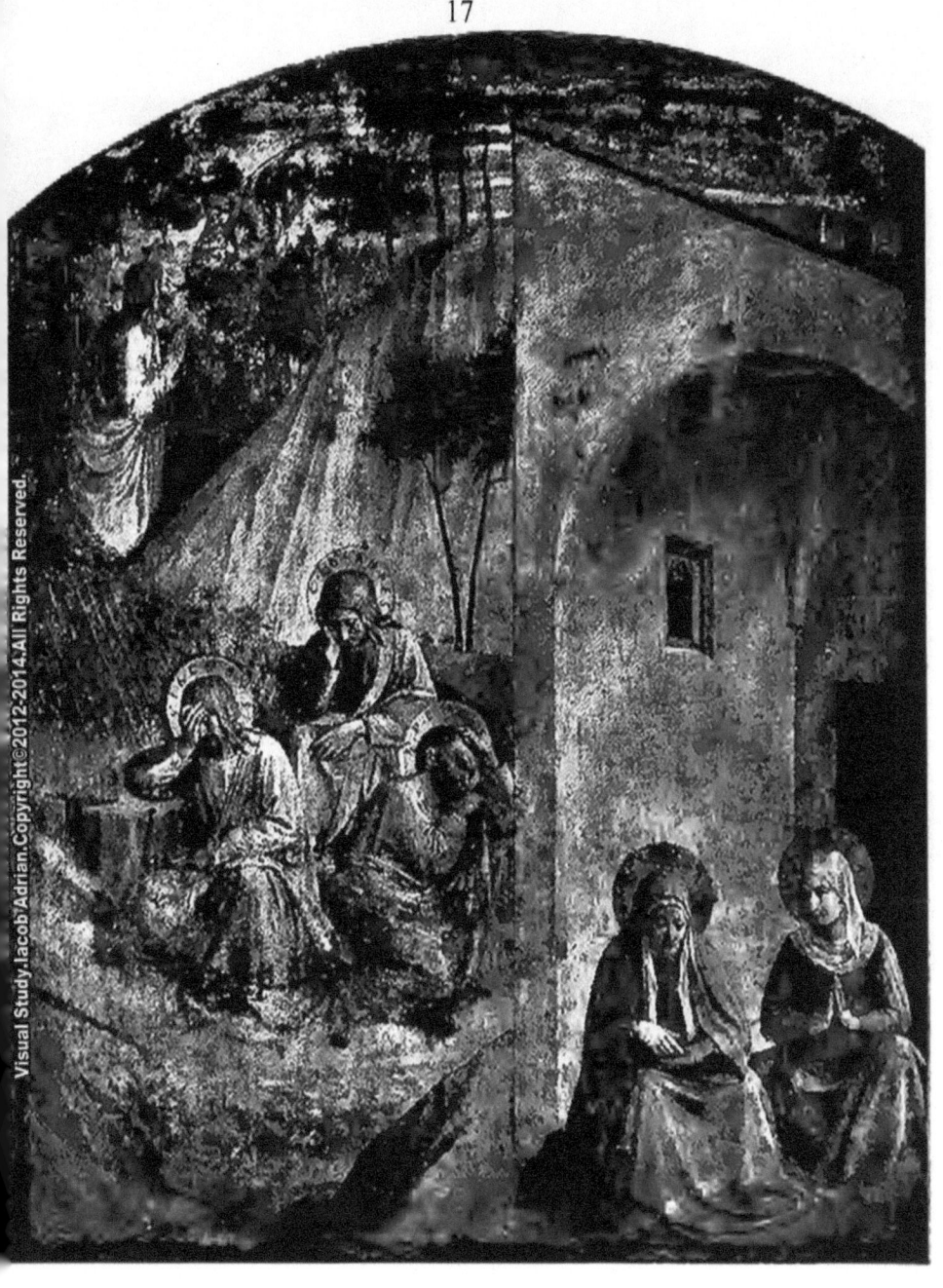

THE AGONY IN THE GARDEN L'AGONIE DE NOTRE-SEIGNEUR
(FRESCO) (FRESQUE)
(St. Mark's, Florence) (Église St-Marc, Florence)
CHRISTI TODESKAMPF IM GARTEN (FRESKE)
(Florenz, Markuskirche)
D. Anderson, Photo.

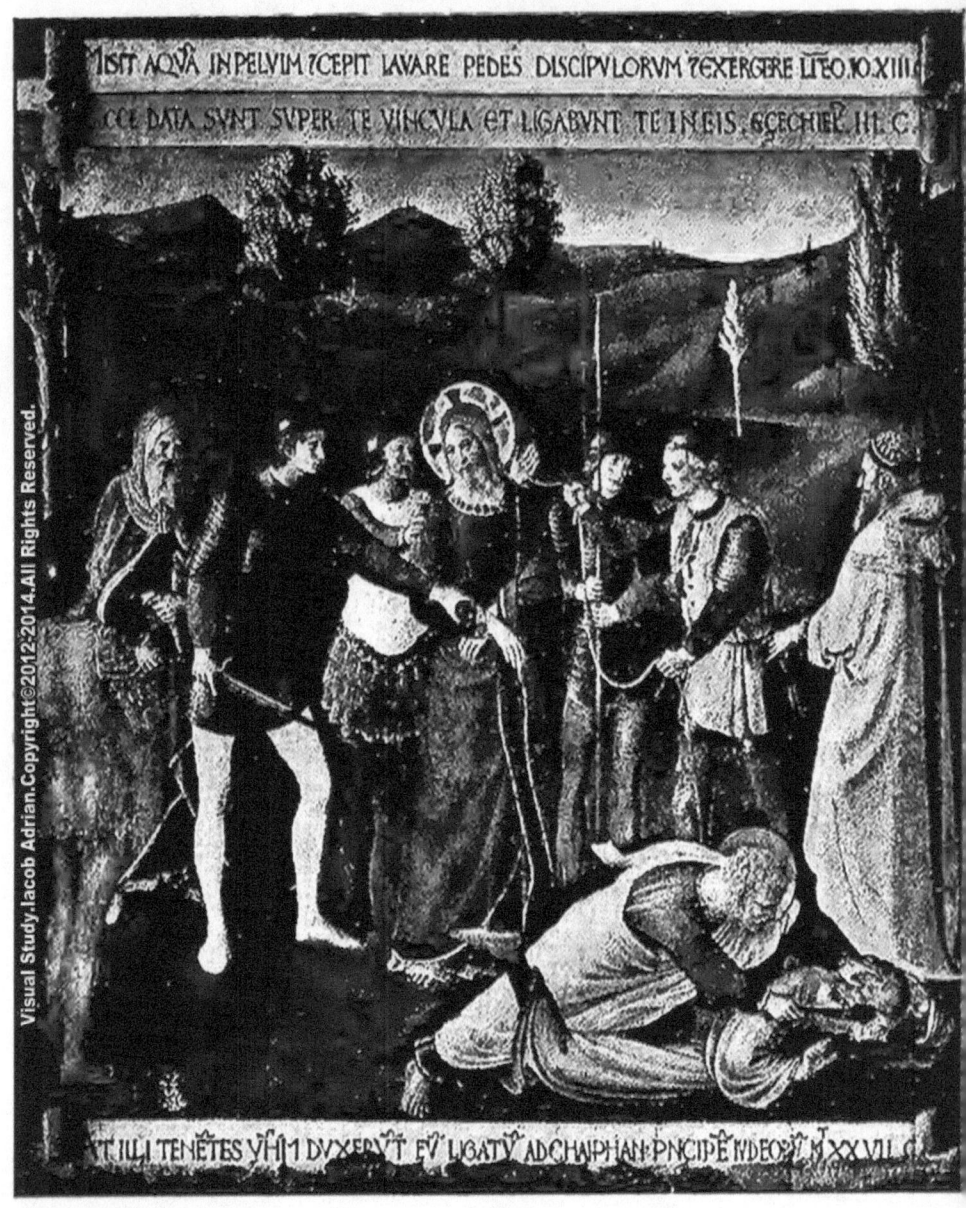

JESUS MADE PRISONER
(Academy, Florence)

JÉSUS FAIT PRISONNIER
(Académie, Florence)

CHRISTUS GEFANGEN
(Florenz, Akademie)
Frat. Alinari, Photo.

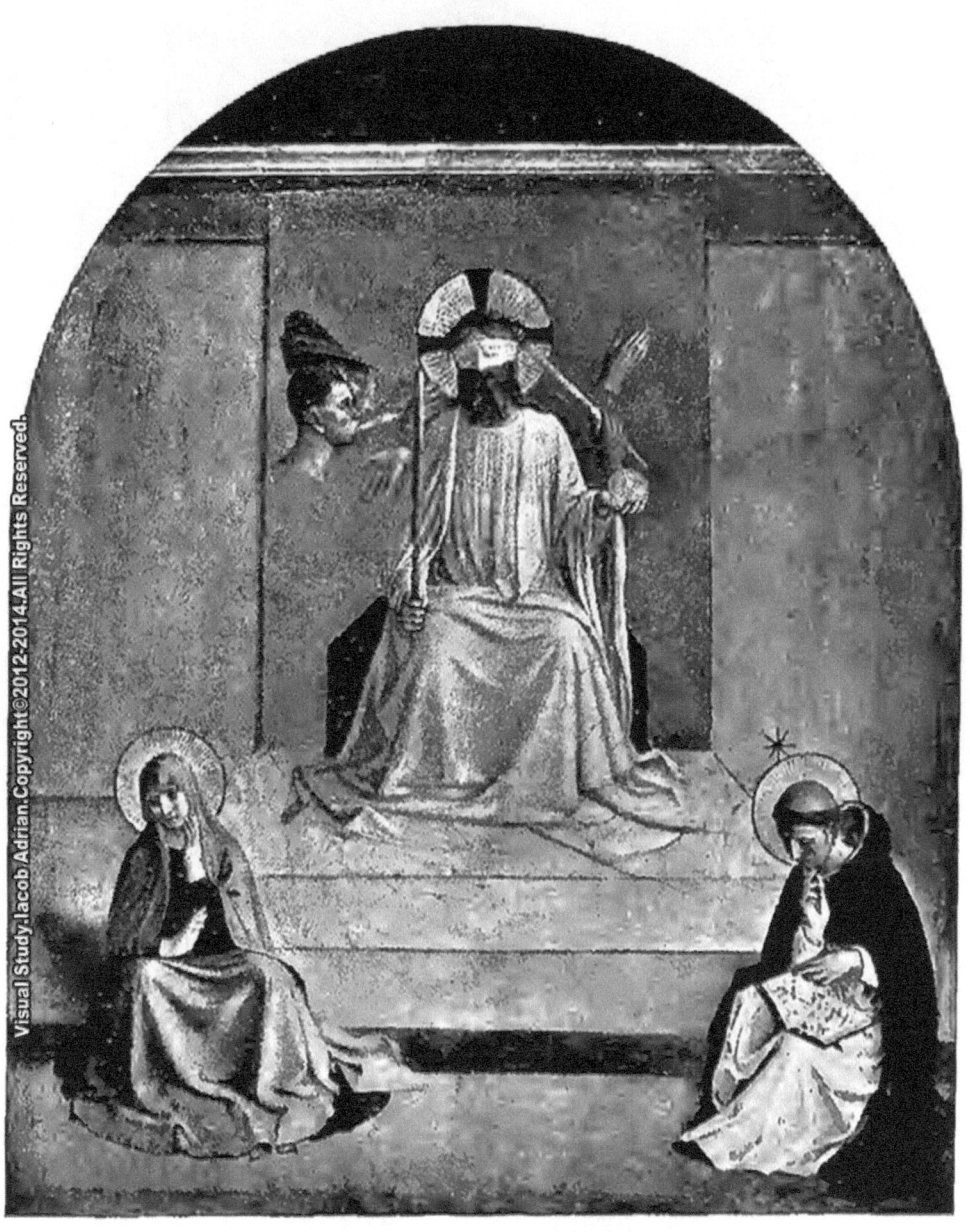

JESUS MOCKED (FRESCO) LE CHRIST MOQUÉ (FRESQUE)
(St. Mark's, Florence) (Église St-Marc, Florence)
DIE VERSPOTTUNG CHRISTI (FRESKE)
(Florenz, Markuskirche)
D. Anderson, Photo.

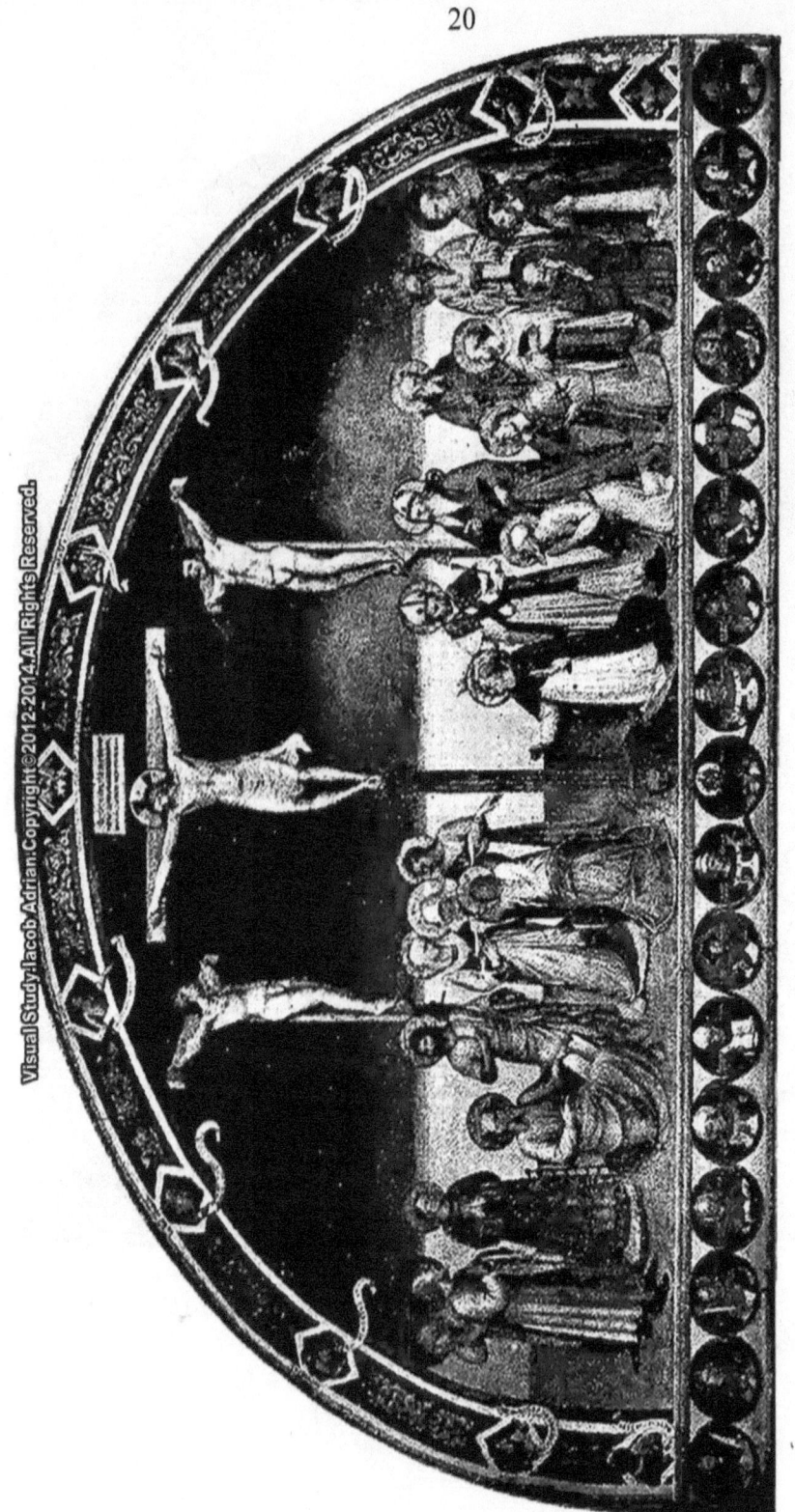

THE CRUCIFIXION (FRESCO)
(*St. Mark's, Florence*)

DIE KREUZIGUNG (FRESKE)
(*Florenz, Markuskirche*)

LA CRUCIFIXION (FRESQUE)
(*Église St-Marc, Florence*)

D. Anderson, Photo.

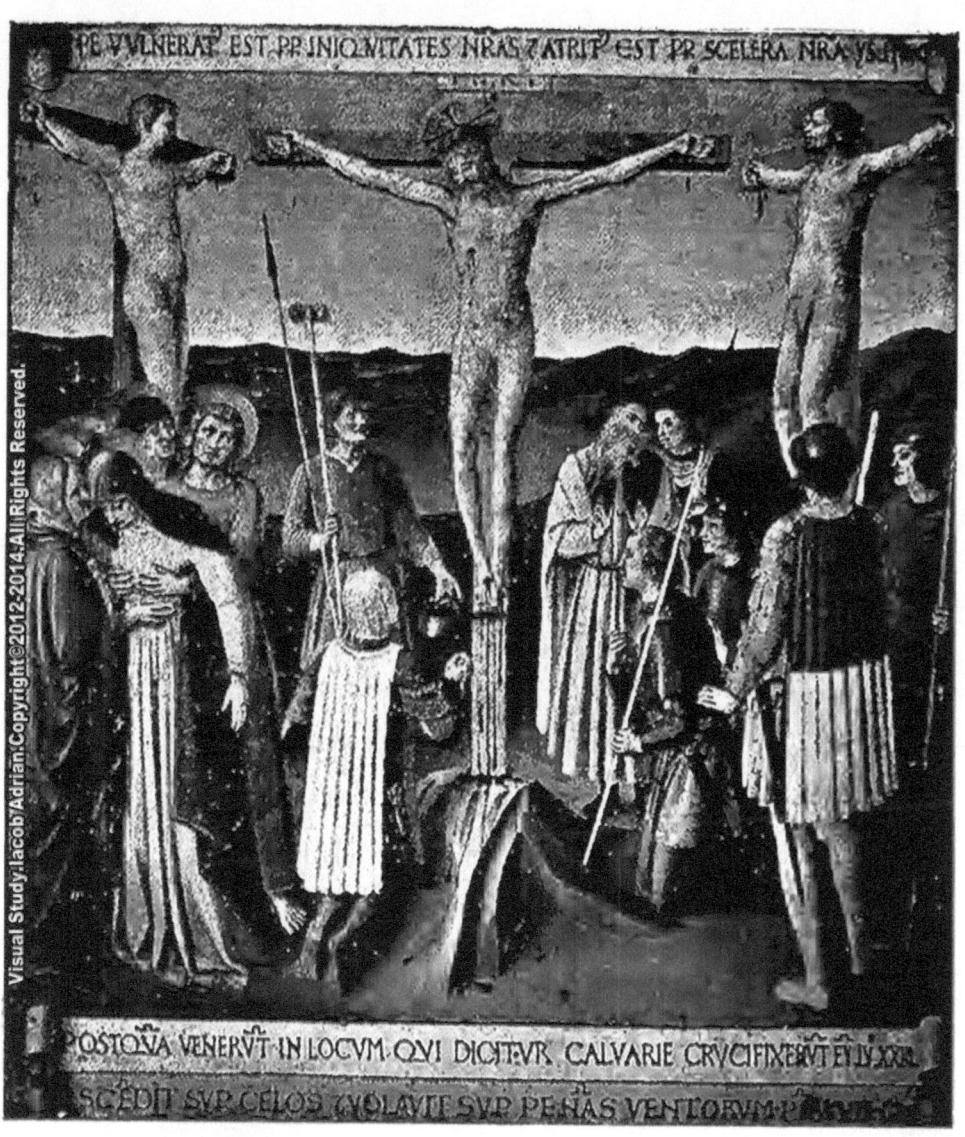

THE CRUCIFIXION
(*Academy, Florence*)

DIE KREUZIGUNG
(*Florenz, Akademie*)
D. Anderson, Photo.

LA CRUCIFIXION
(*Académie, Florence*)

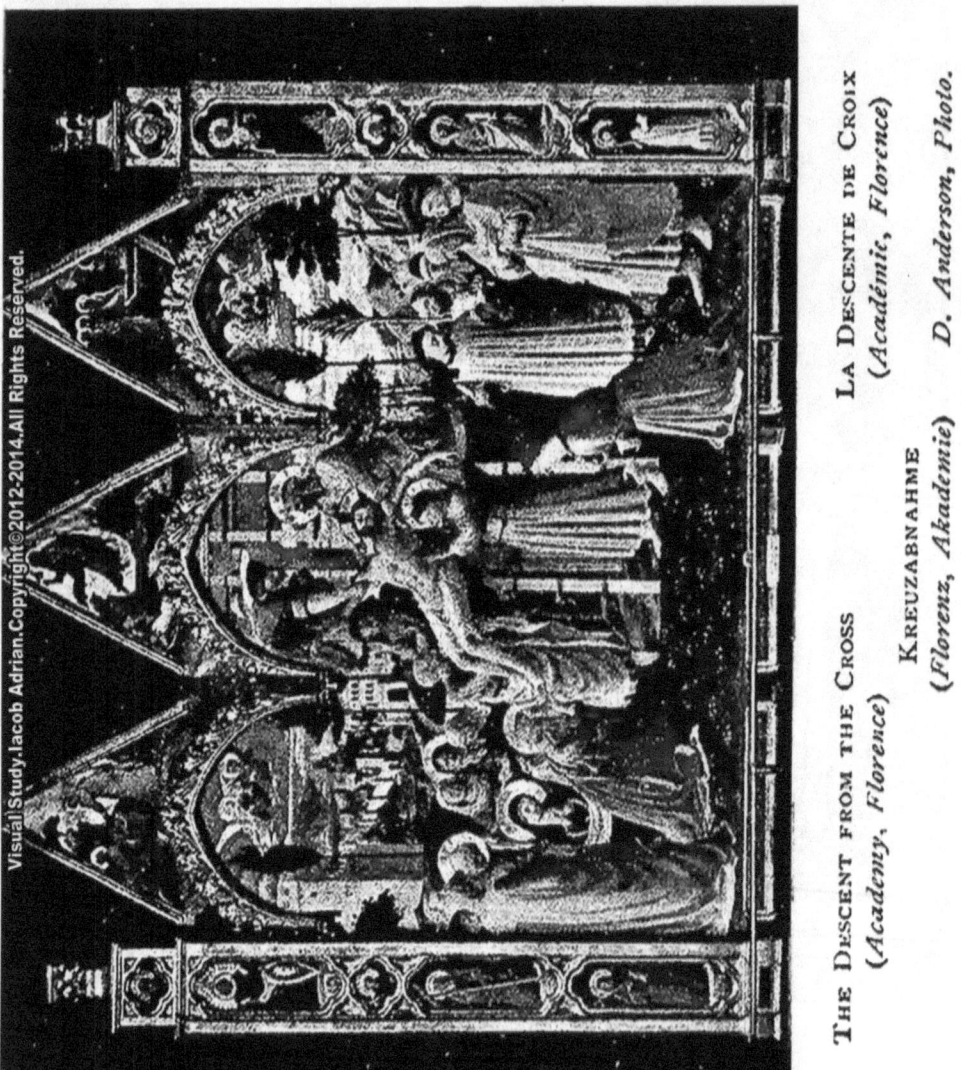

The Descent from the Cross La Descente de Croix
(Academy, Florence) (Académie, Florence)

Kreuzabnahme
(Florenz, Akademie) D. Anderson, Photo.

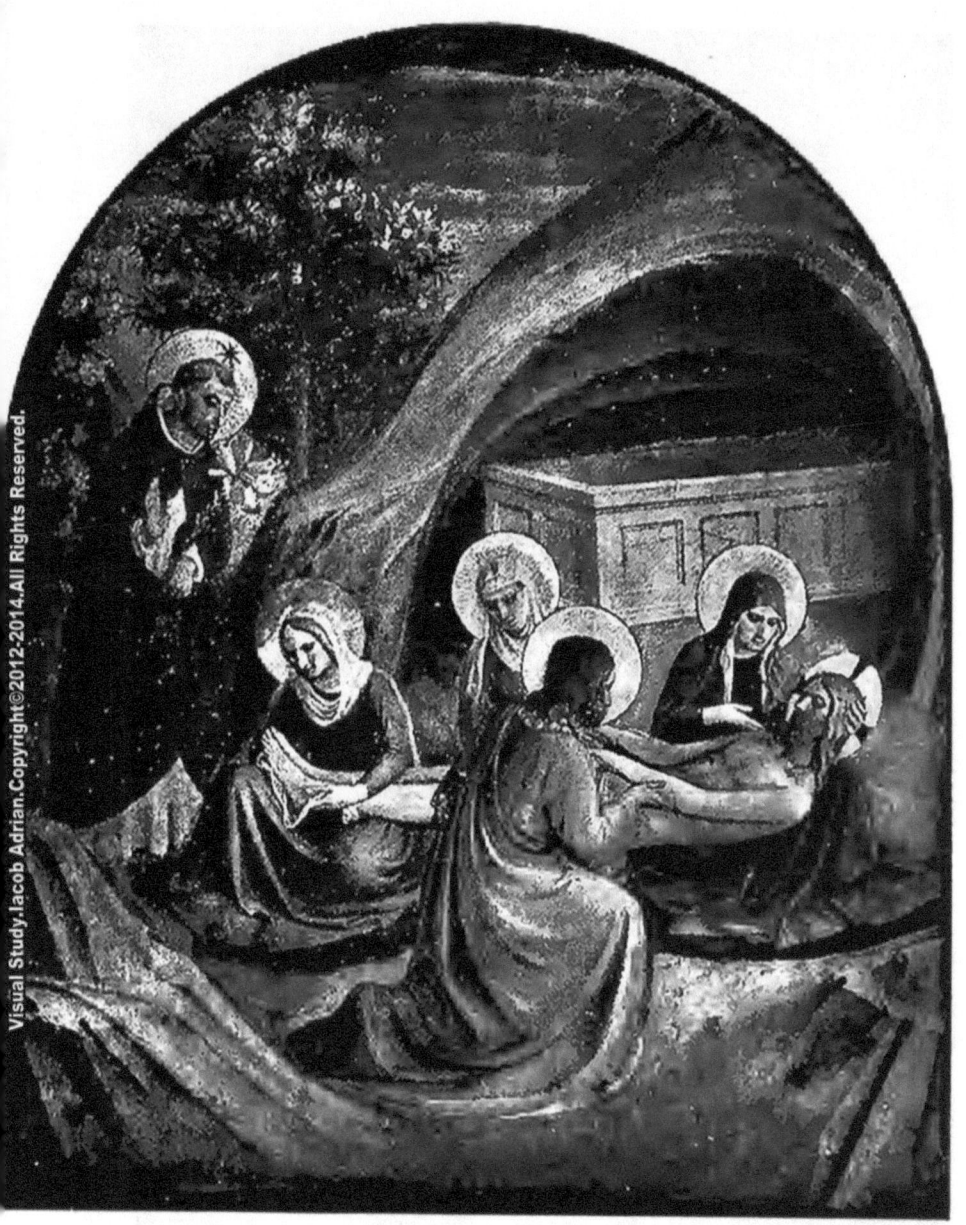

THE ENTOMBMENT (FRESCO) LA MISE AU TOMBEAU (FRESQUE)
(St. Mark's, Florence) (Église St-Marc, Florence)
DIE GRABLEGUNG CHRISTI (FRESKE)
(Florenz, Markuskirche)
D. Anderson, Photo.

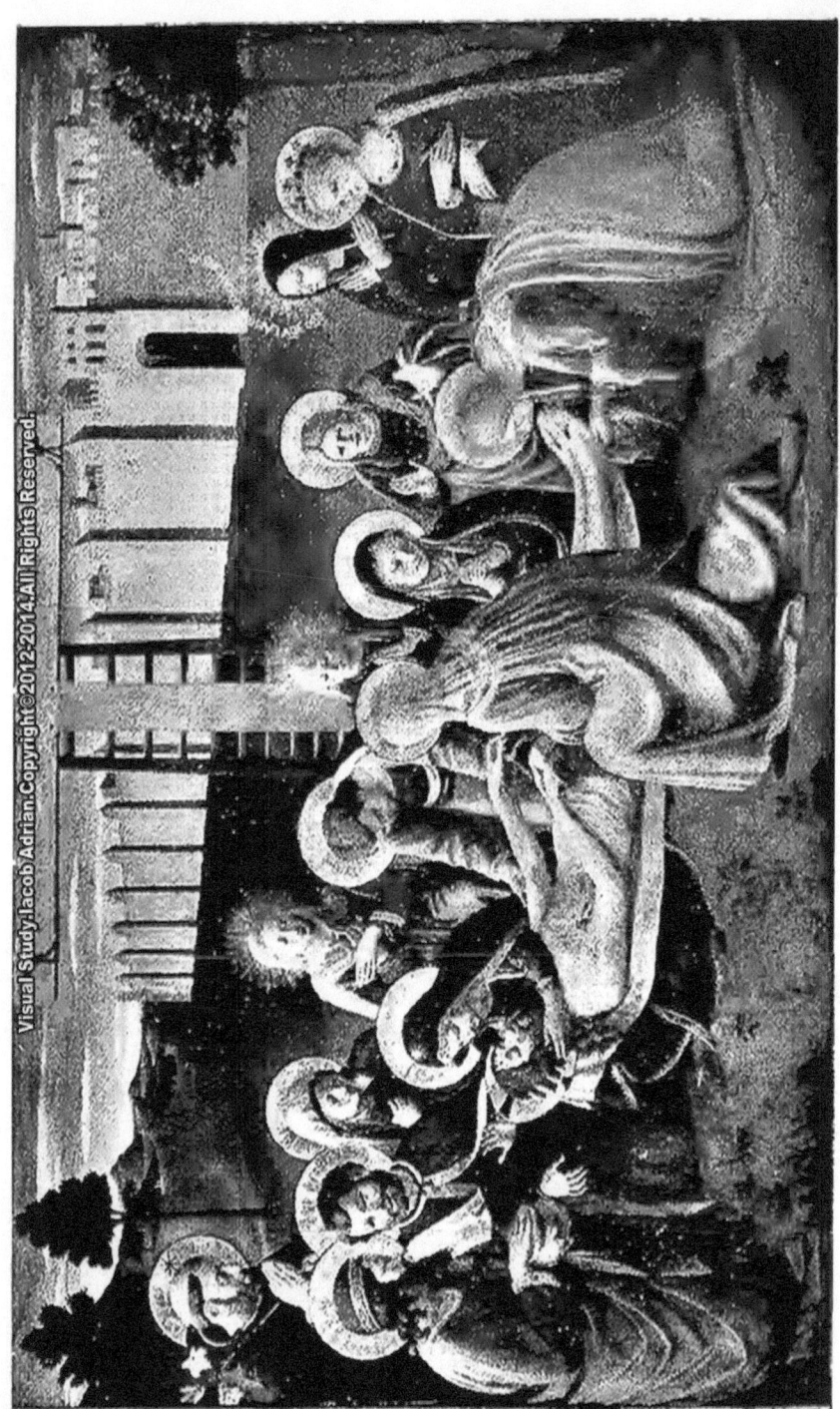

THE ENTOMBMENT
(Academy, Florence)

DIE GRABLEGUNG CHRISTI
(Florenz, Akademie)
D. Anderson, Photo.

LA MISE AU TOMBEAU
(Académie, Florence)

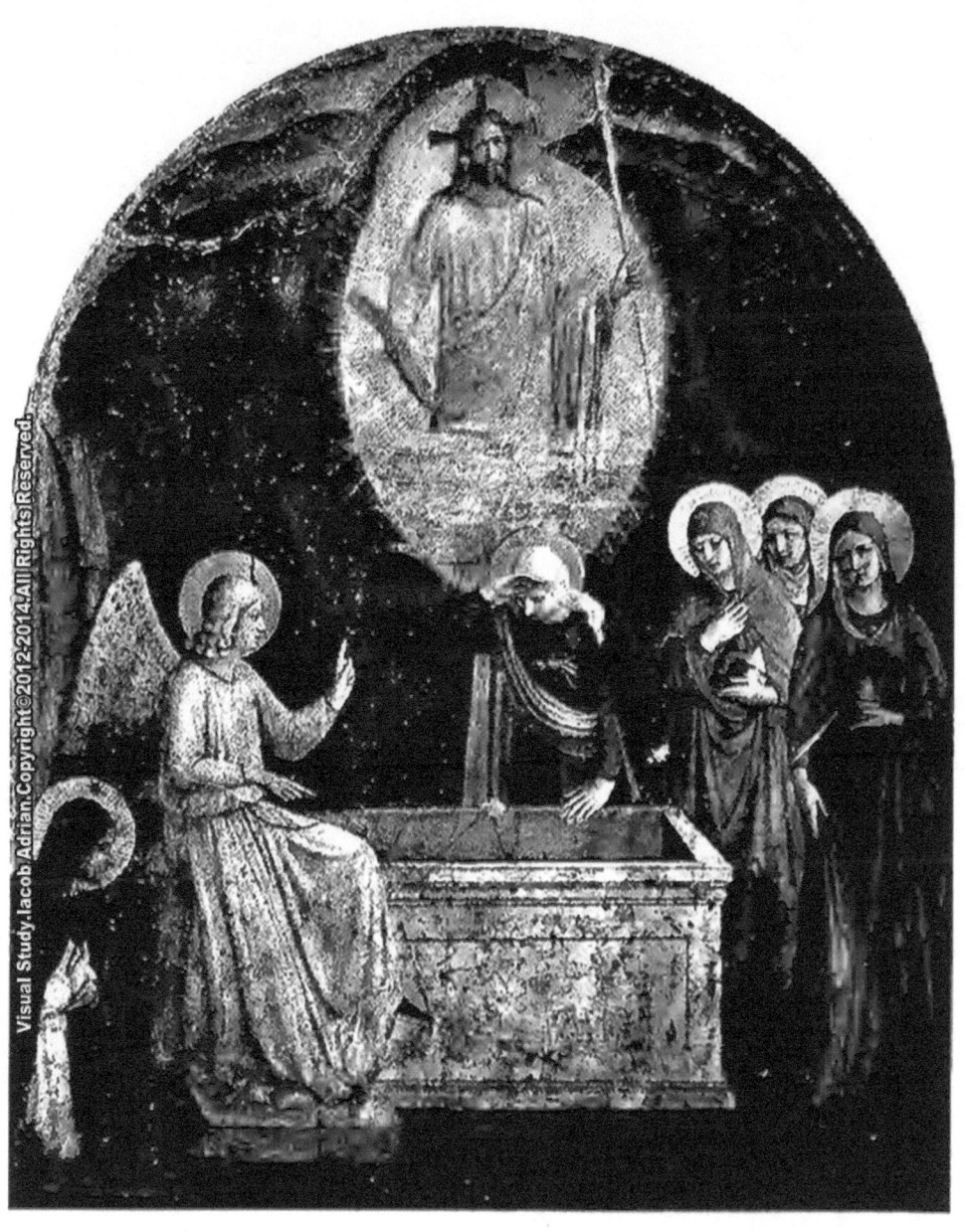

THE RESURRECTION (FRESCO) LA RÉSURRECTION (FRESQUE)
(St. Mark's, Florence) (Église St-Marc, Florence)
DIE AUFERSTEHUNG CHRISTI (FRESKE)
(Florenz, Markuskirche)
D. Anderson, Photo.

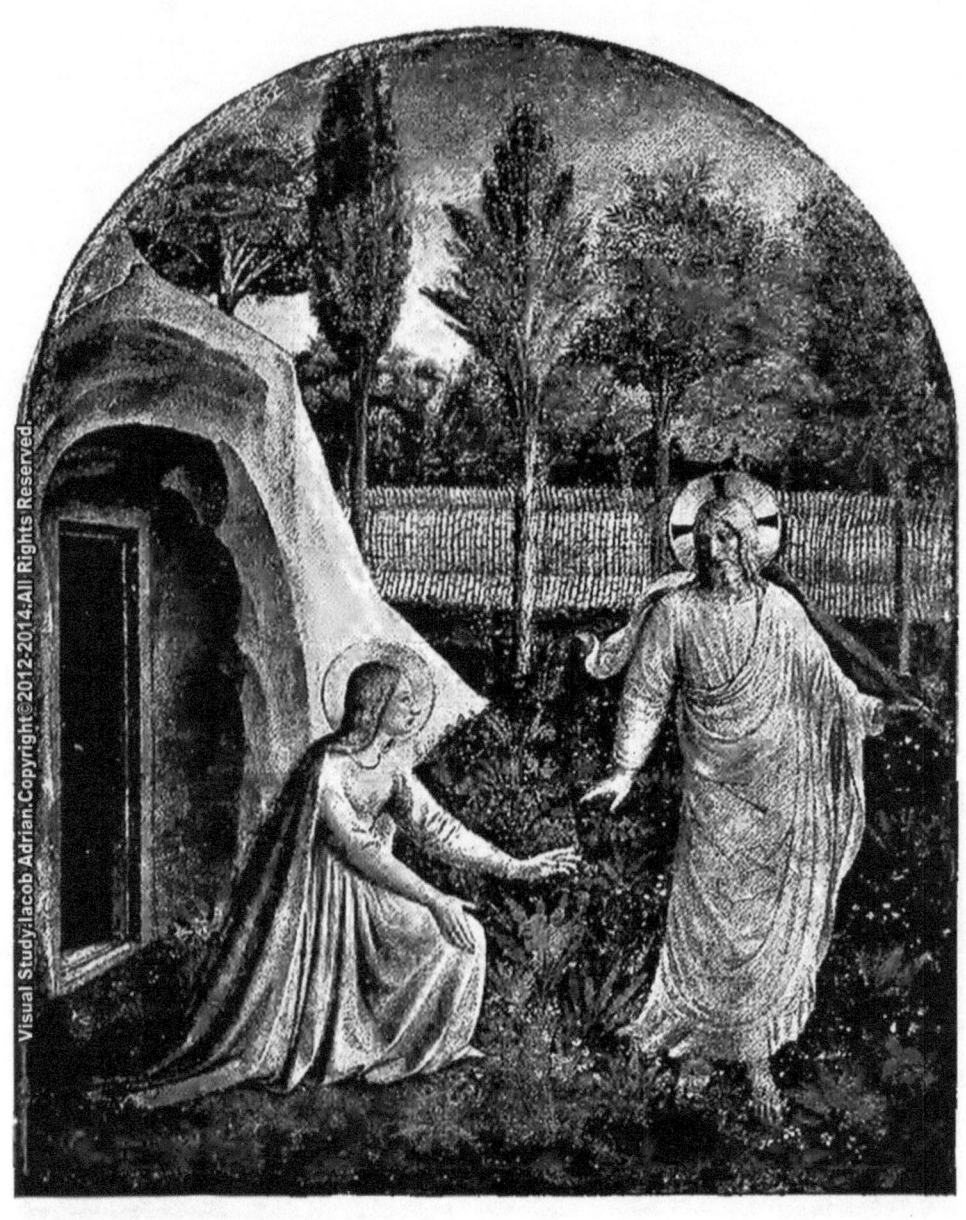

"Noli me tangere" (Fresco) (St. Mark's, Florence)

"Noli me tangere" (Fresque) (Église St-Marc, Florence)

"Noli me tangere" (Freske) (Florenz, Markuskirche)

D. Anderson, Photo.

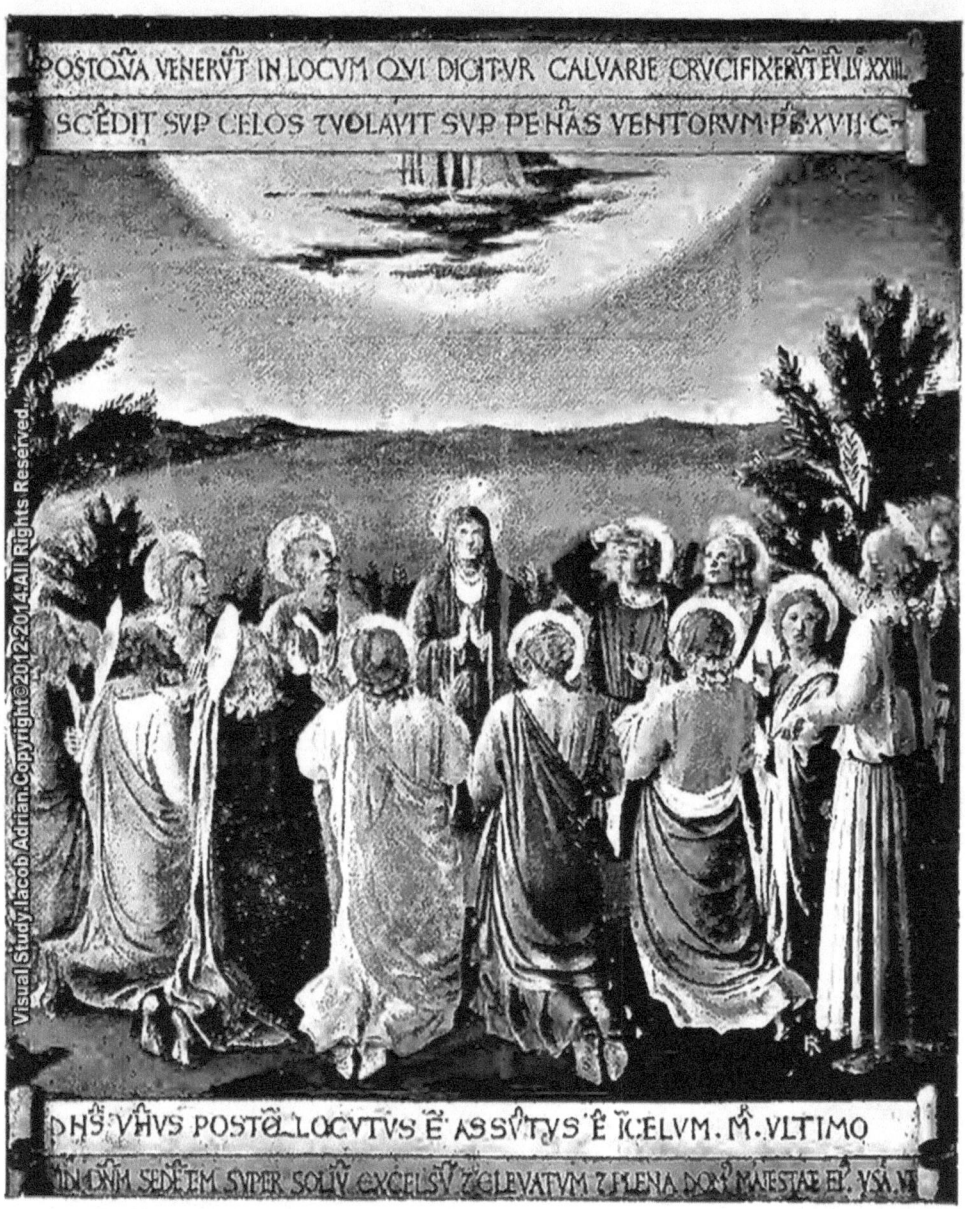

THE ASCENSION
(*Academy, Florence*)

L'ASCENSION
(*Académie, Florence*)

DIE HIMMELFAHRT CHRISTI
(*Florenz, Akademie*)
D. Anderson, Photo.

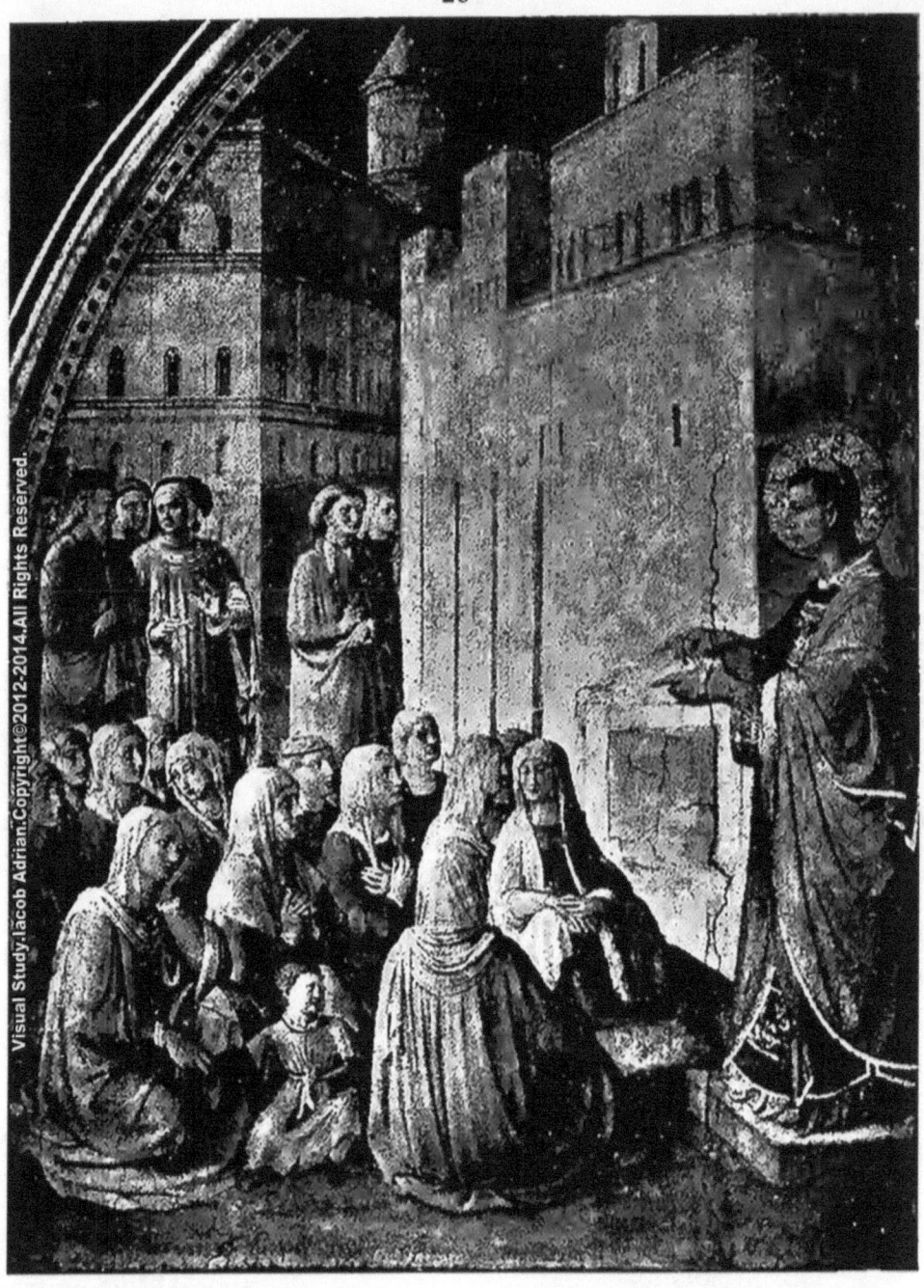

St. Stephen preaching to the People (Fresco)
(Vatican, Rome)

St Étienne prêchant au Peuple (Fresque)
(Vatican, Rome)

St. Stephan dem Volke Predigend (Freske)
(Rom, Vatikan) D. Anderson, Photo.

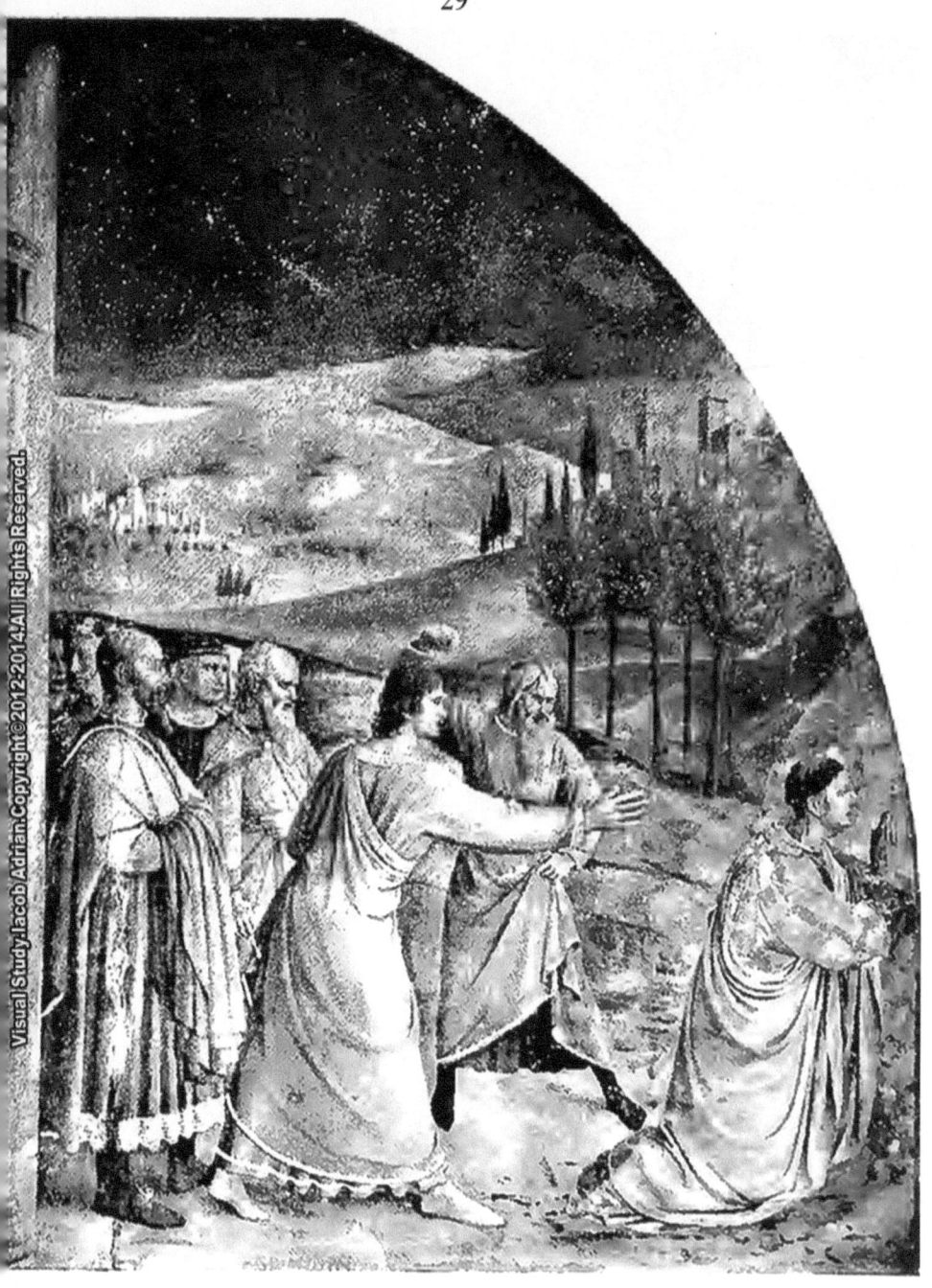

THE STONING OF ST. STEPHEN LA LAPIDATION DE ST ÉTIENNE
(FRESCO) (FRESQUE)
(*Vatican, Rome*) (*Vatican, Rome*)
DIE STEINIGUNG DES HL. STEPHAN (FRESKE)
(*Rom, Vatikan*) D. Anderson. Photo.

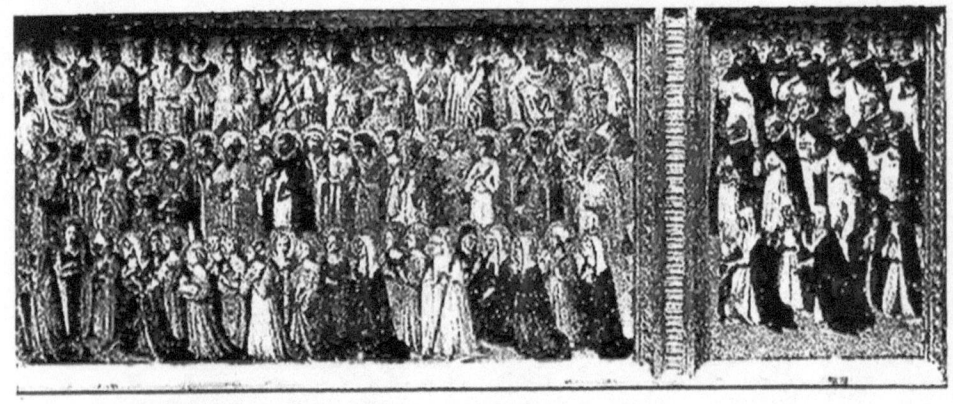

CHRIST IN GLORY [PREDELLA] LE CHRIST EN SA GLOIRE
(*National Gallery, London*) (*Galerie nationale, Londres*)
CHRISTUS IN DER GLORIE
(*London, Nationalgalerie*)
F. Hanfstaengl, Photo.

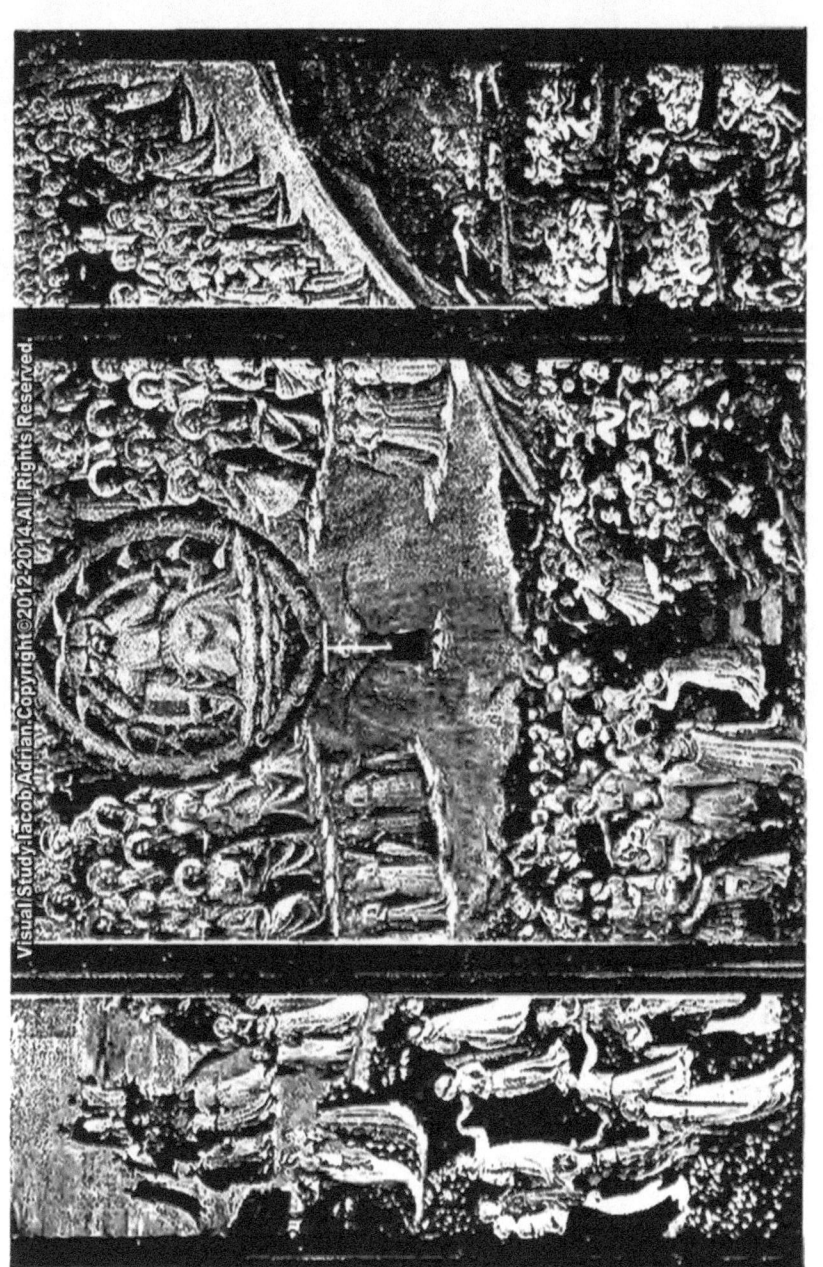

The Last Judgment
(Royal Gallery, Berlin)

Das jüngste Gericht
(Berlin, Kgl. Galerie)

Le Jugement dernier
(Galerie royale, Berlin)

F. Hanfstaengl, Photo.

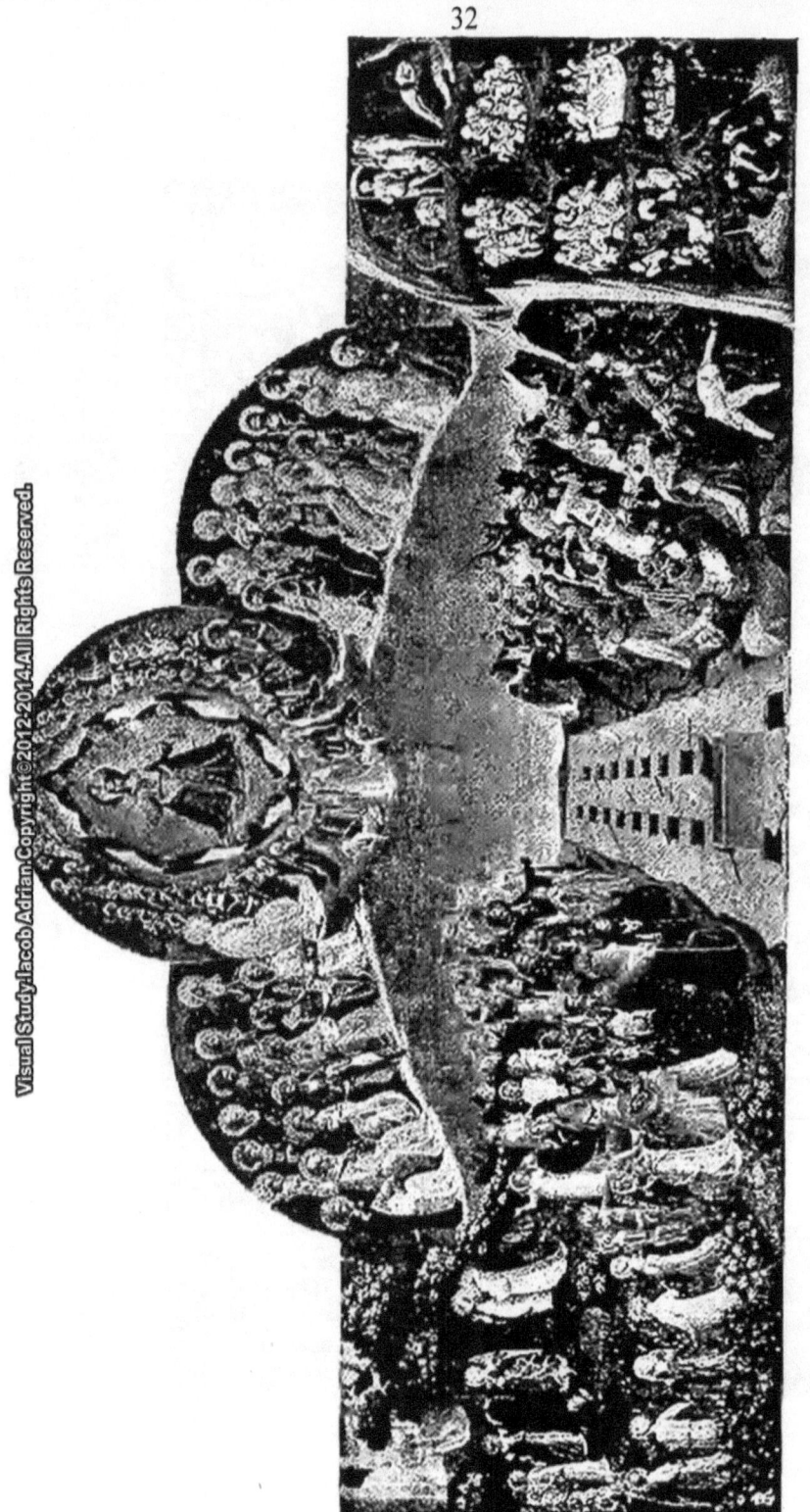

THE LAST JUDGMENT
(Academy, Florence)

DAS JÜNGSTE GERICHT
(Florenz, Akademie)
D. Anderson, Photo.

LE JUGEMENT DERNIER
(Académie, Florence)

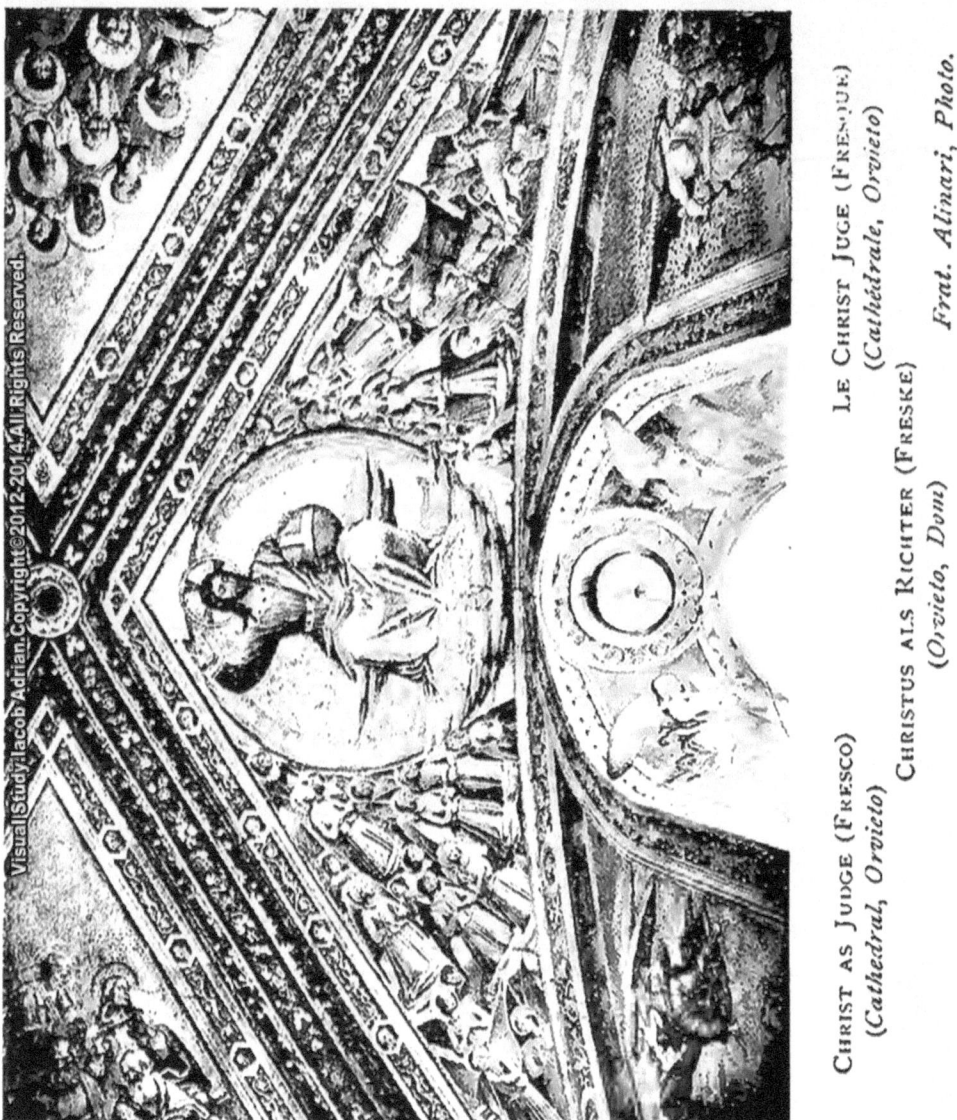

CHRIST AS JUDGE (FRESCO)　　　LE CHRIST JUGE (FRESQUE)
(Cathedral, Orvieto)　　　　　(Cathédrale, Orvieto)
CHRISTUS ALS RICHTER (FRESKE)
(Orvieto, Dom)
Frat. Alinari, Photo.

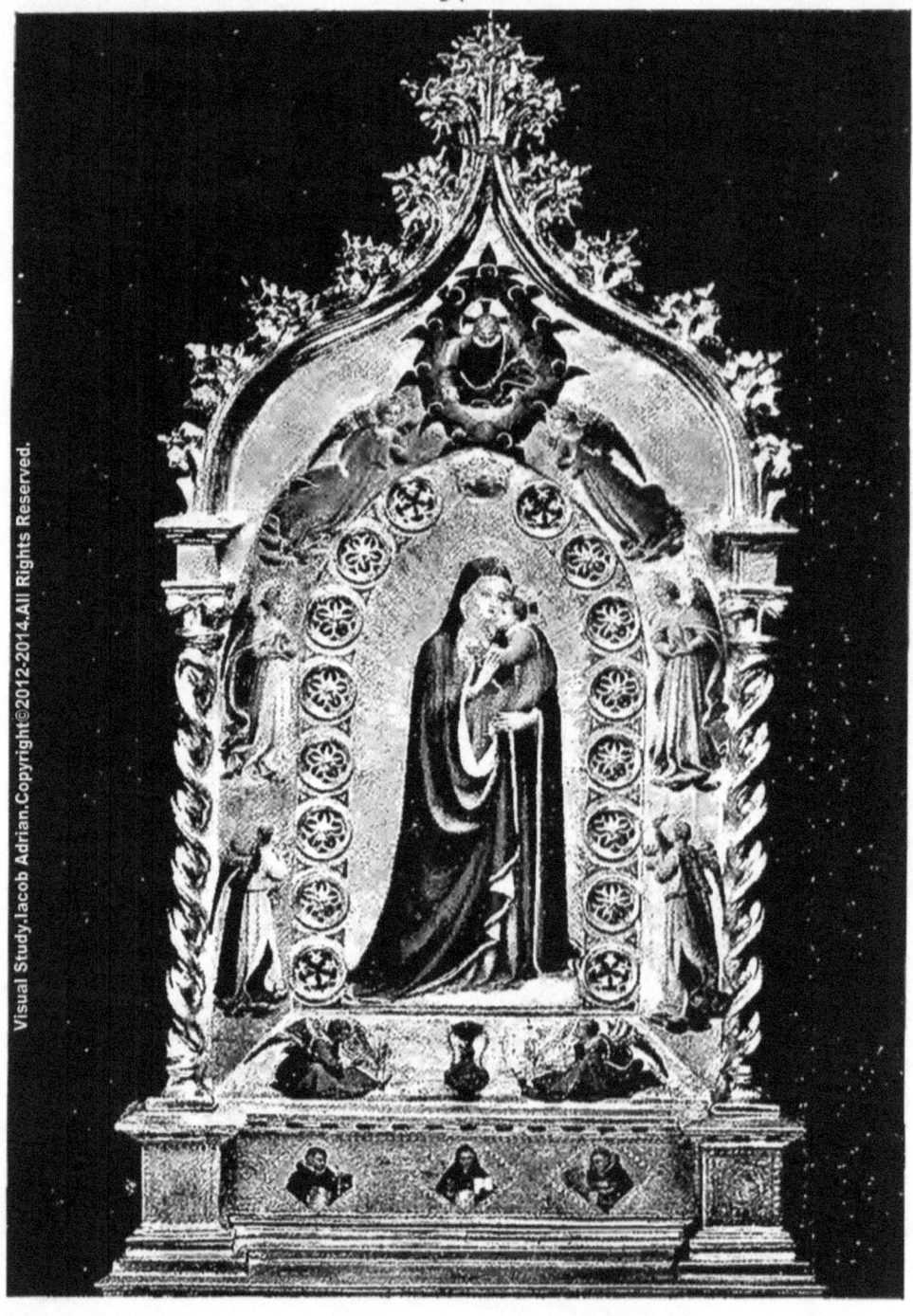

THE VIRGIN AND CHILD
("MADONNA DELLA STELLA")
(*St. Mark's, Florence*)

LA VIERGE ET L'ENFANT
(*Église St-Marc, Florence*)

MARIA MIT DEM KINDE
(*Florenz, Markuskirche*) D. Anderson, Photo.

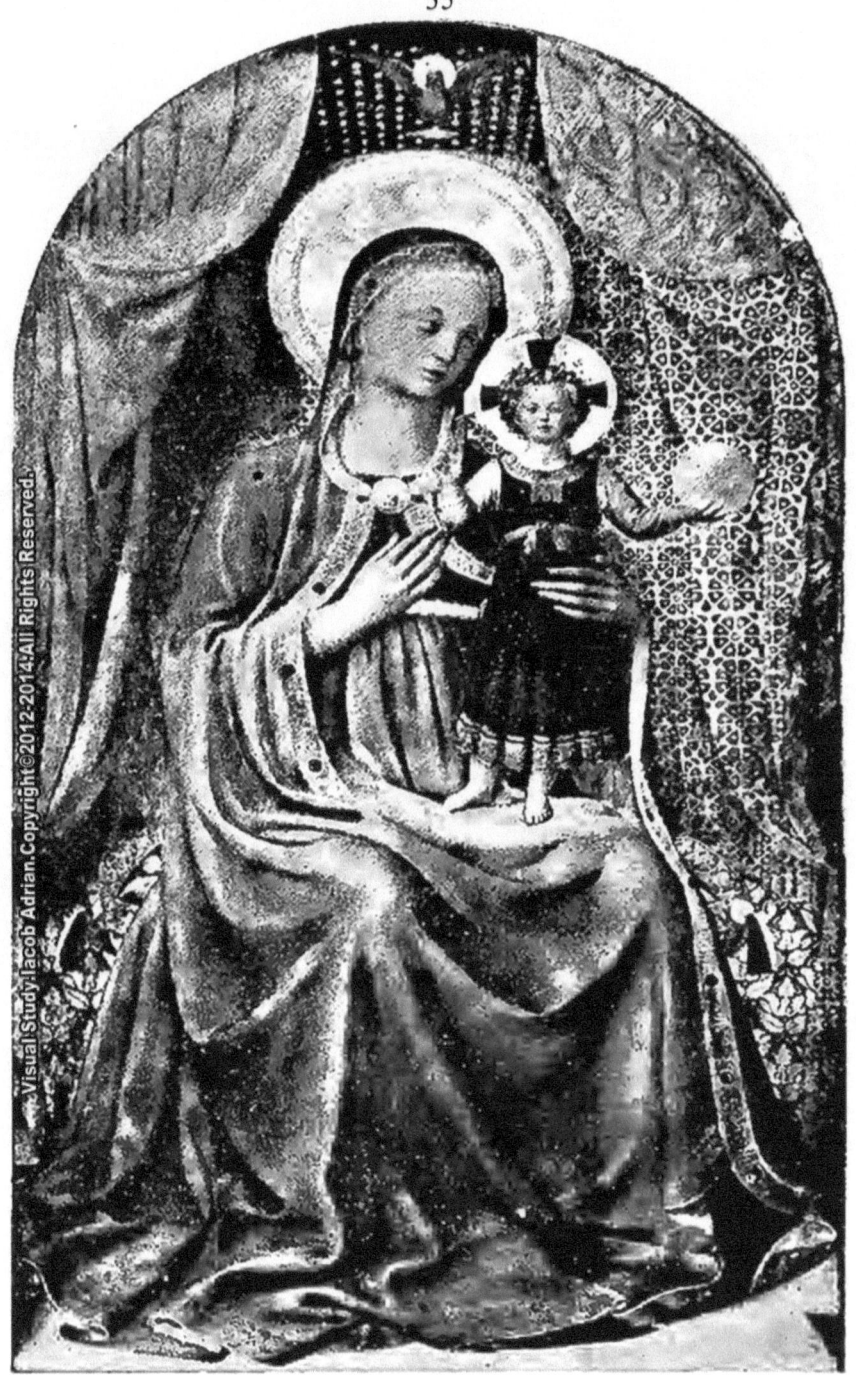

THE VIRGIN AND CHILD
MADONNA DEI LINAJUOLI")
(*Uffizi, Florence*)

LA VIERGE ET L'ENFANT
(*Galerie des Offices, Florence*)

MARIA MIT DEM KINDE
(*Florenz, Uffizien*) F. *Hanfstaengl, Photo.*

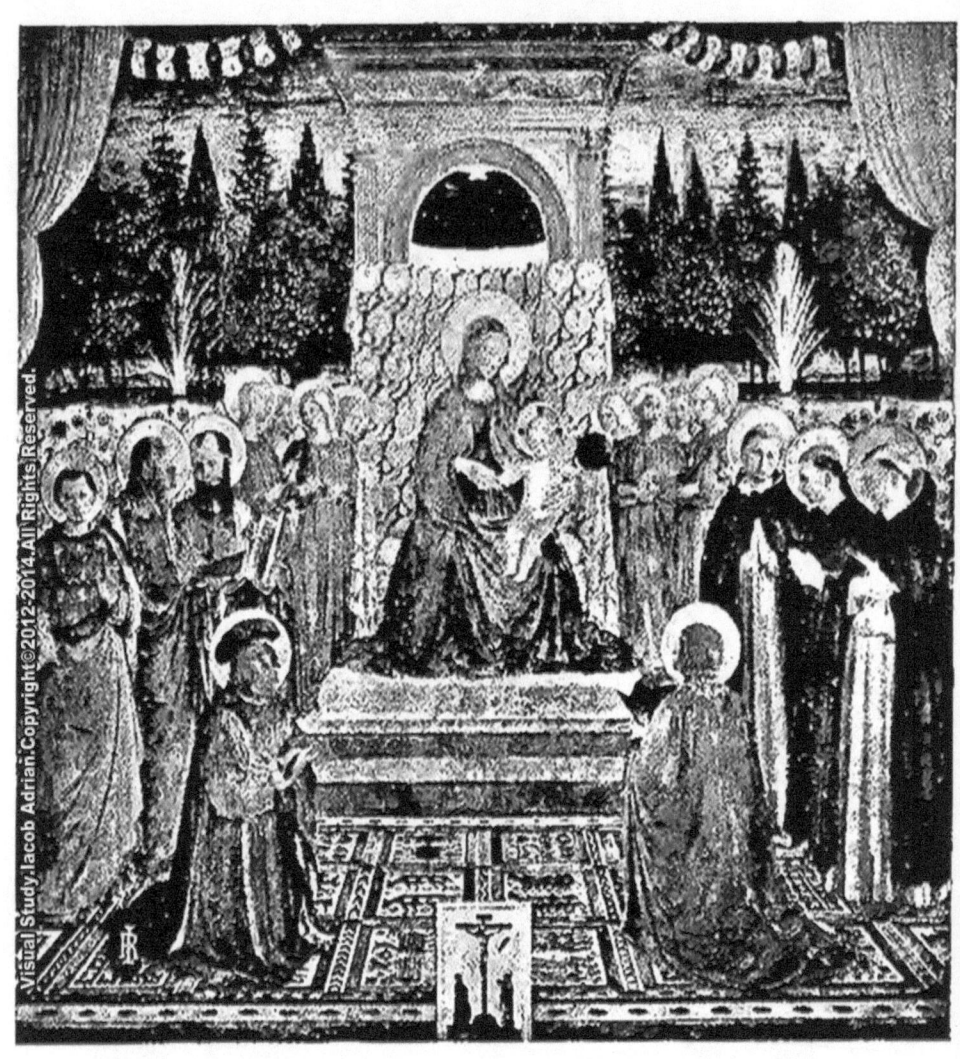

THE VIRGIN AND CHILD
WITH SAINTS
("MADONNA DI SAN MARCO")
(*Academy, Florence*)

LA VIERGE ET L'ENFANT
AVEC DES SAINTS
(*Académie, Florence*)

MARIA MIT DEM KINDE UND HEILIGEN
(*Florenz, Akademie*)

Frat. Alinari, Photo

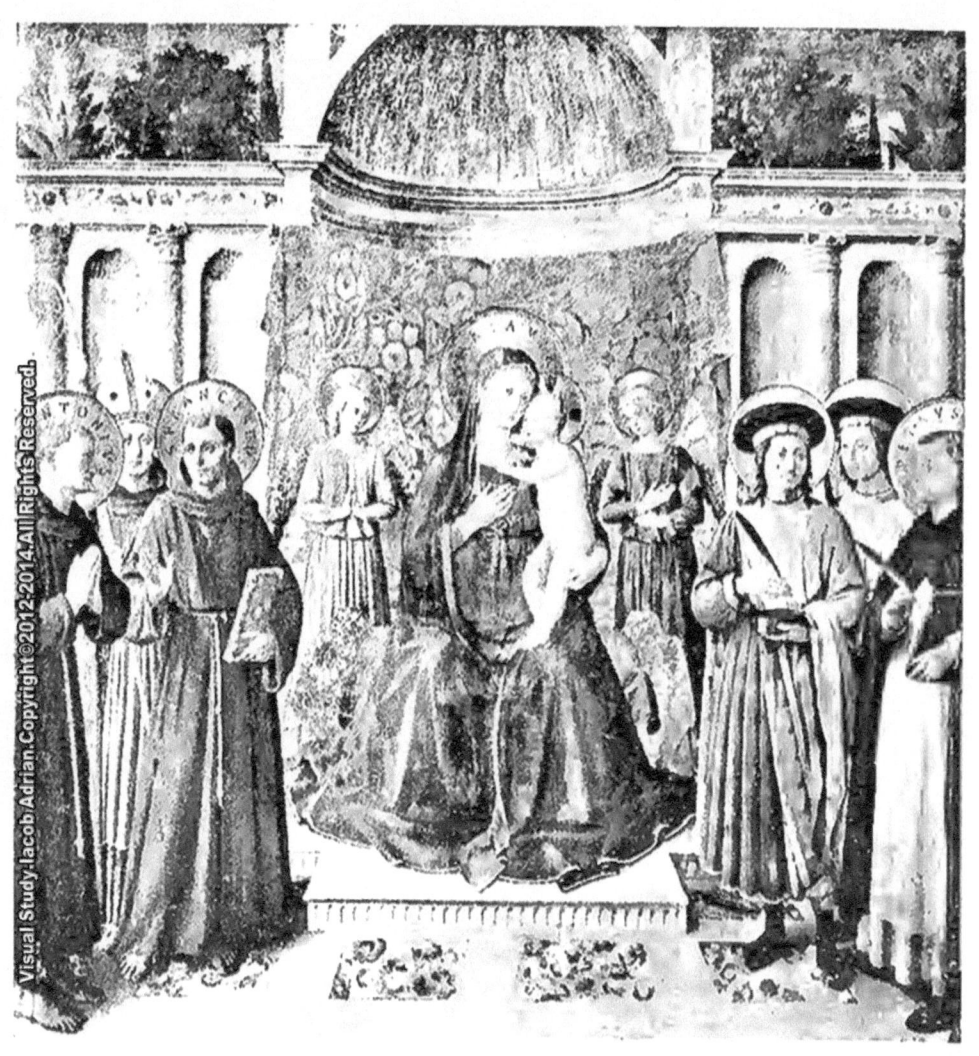

The Virgin and Child
with Saints
("Madonna di S. Bonaventura
al Bosco")
(*Academy, Florence*)

La Vierge et l'Enfant
avec des Saints
(*Académie, Florence*)

Maria mit dem Kinde und Heiligen
(*Florenz, Akademie*) *Frat. Alinari, Photo.*

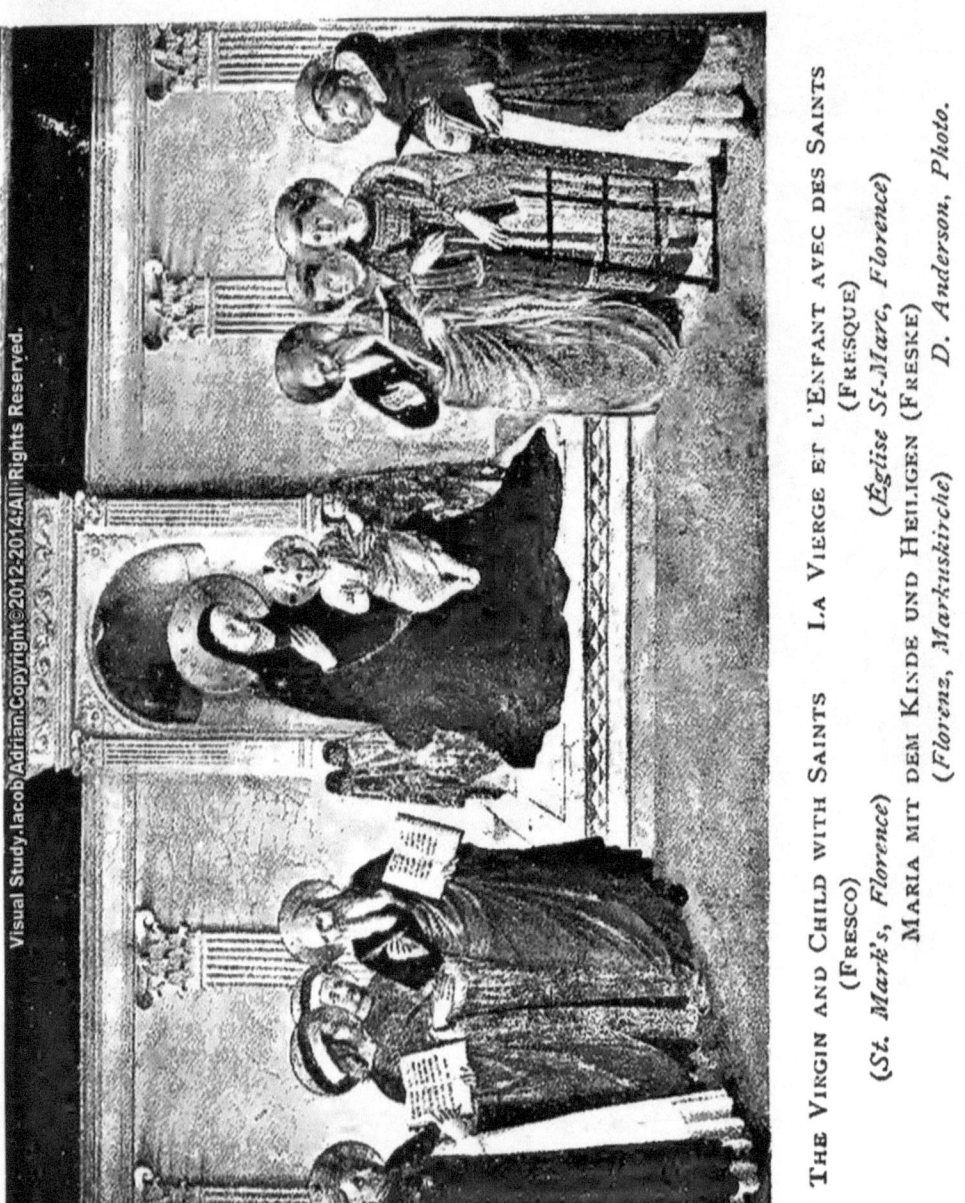

The Virgin and Child with Saints La Vierge et l'Enfant avec des Saints
(Fresco) (Fresque)
(St. Mark's, Florence) (Église St-Marc, Florence)
Maria mit dem Kinde und Heiligen (Freske)
(Florenz, Markuskirche) D. Anderson, Photo.

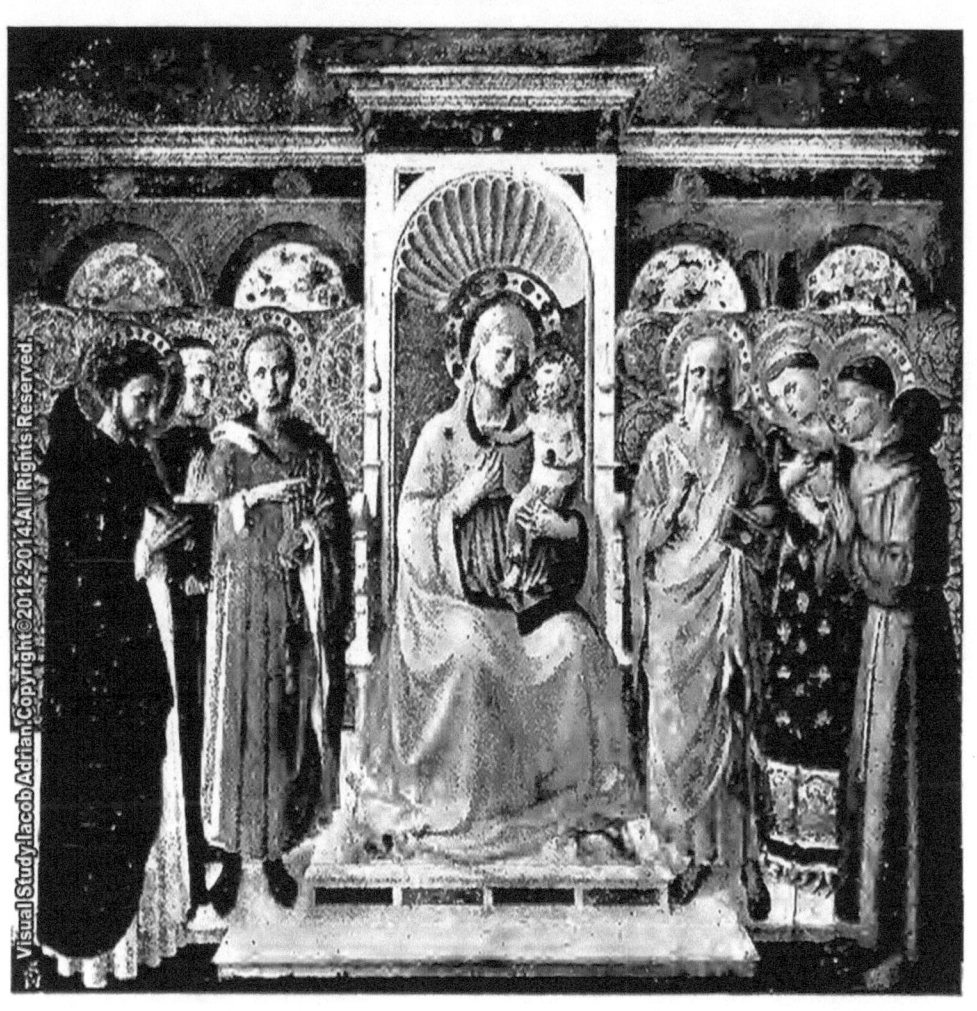

THE VIRGIN AND CHILD
WITH SAINTS
("MADONNA D'ANNALENA")
(*Academy, Florence*)

LA VIERGE ET L'ENFANT
AVEC DES SAINTS
(*Académie, Florence*)

MARIA MIT DEM KINDE UND HEILIGEN
(*Florenz, Akademie*) *Frat. Alinari, Photo.*

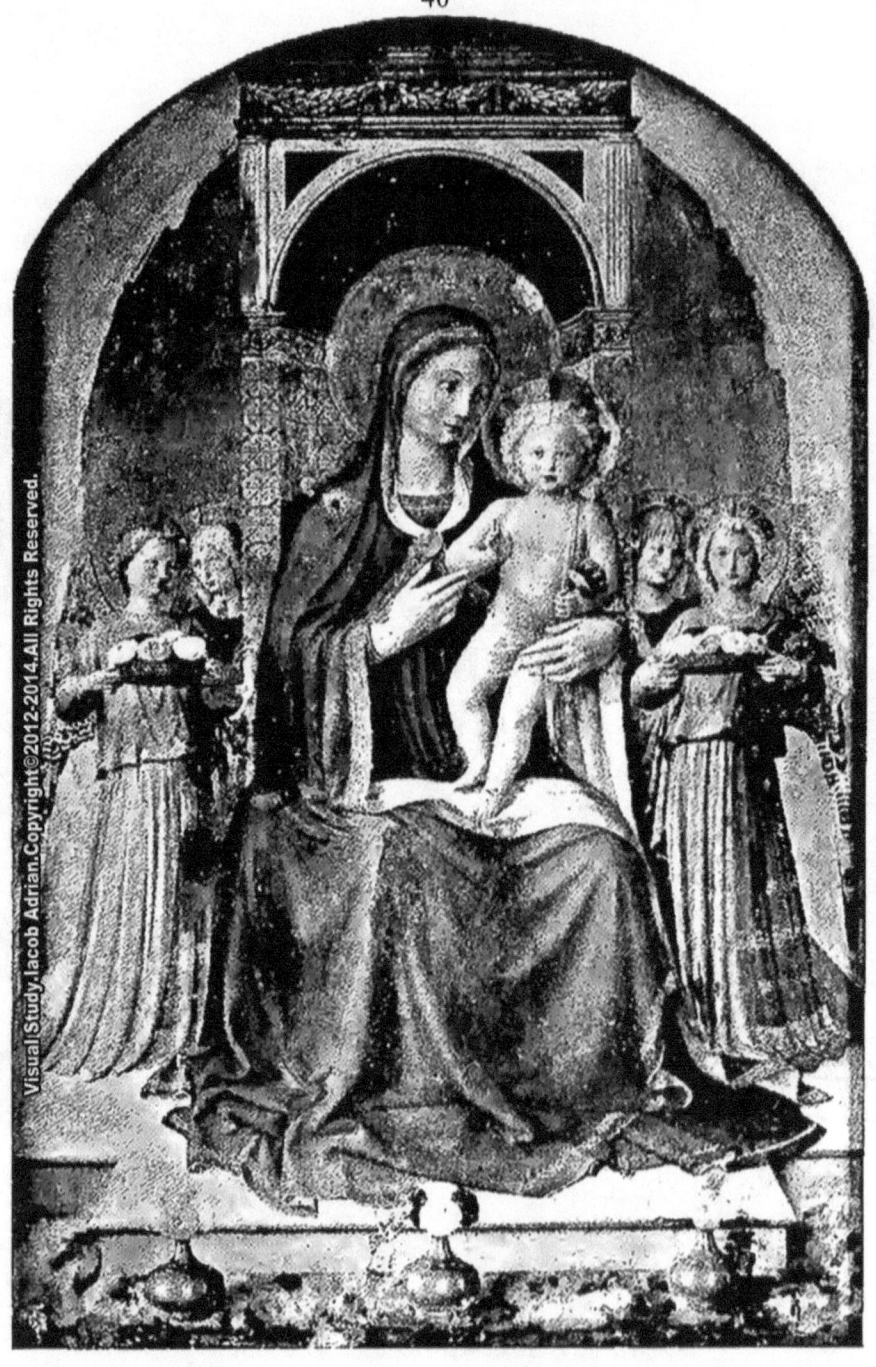

THE VIRGIN AND CHILD WITH ANGELS
("MADONNA DI PERUGIA")
(*Pinacotheca, Perugia*)

LA VIERGE ET L'ENFANT AVEC DES ANGES
(*Pinacothèque, Pérouse*)

MARIA MIT DEM KINDE UND ENGELN
(*Perugia, Pinakothek*) *Frat. Alinari, Photo.*

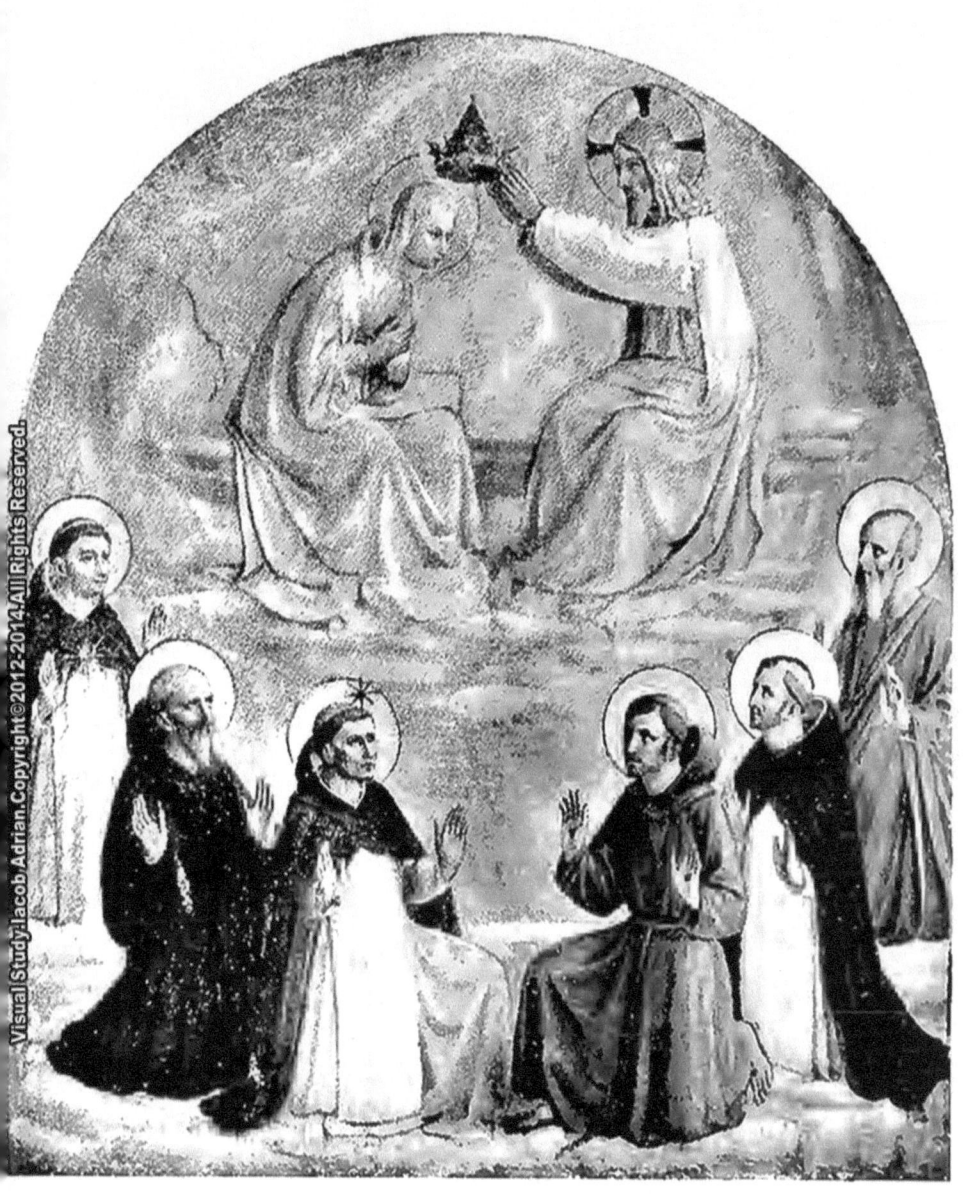

THE CORONATION OF THE
VIRGIN (FRESCO)
(*St. Mark's, Florence*)

LA COURONNEMENT DE LA
VIERGE (FRESQUE)
(*Église St-Marc, Florence*)

DIE KRÖNUNG MARIÄ (FRESKE)
(*Florenz, Markuskirche*)
D. Anderson, Photo.

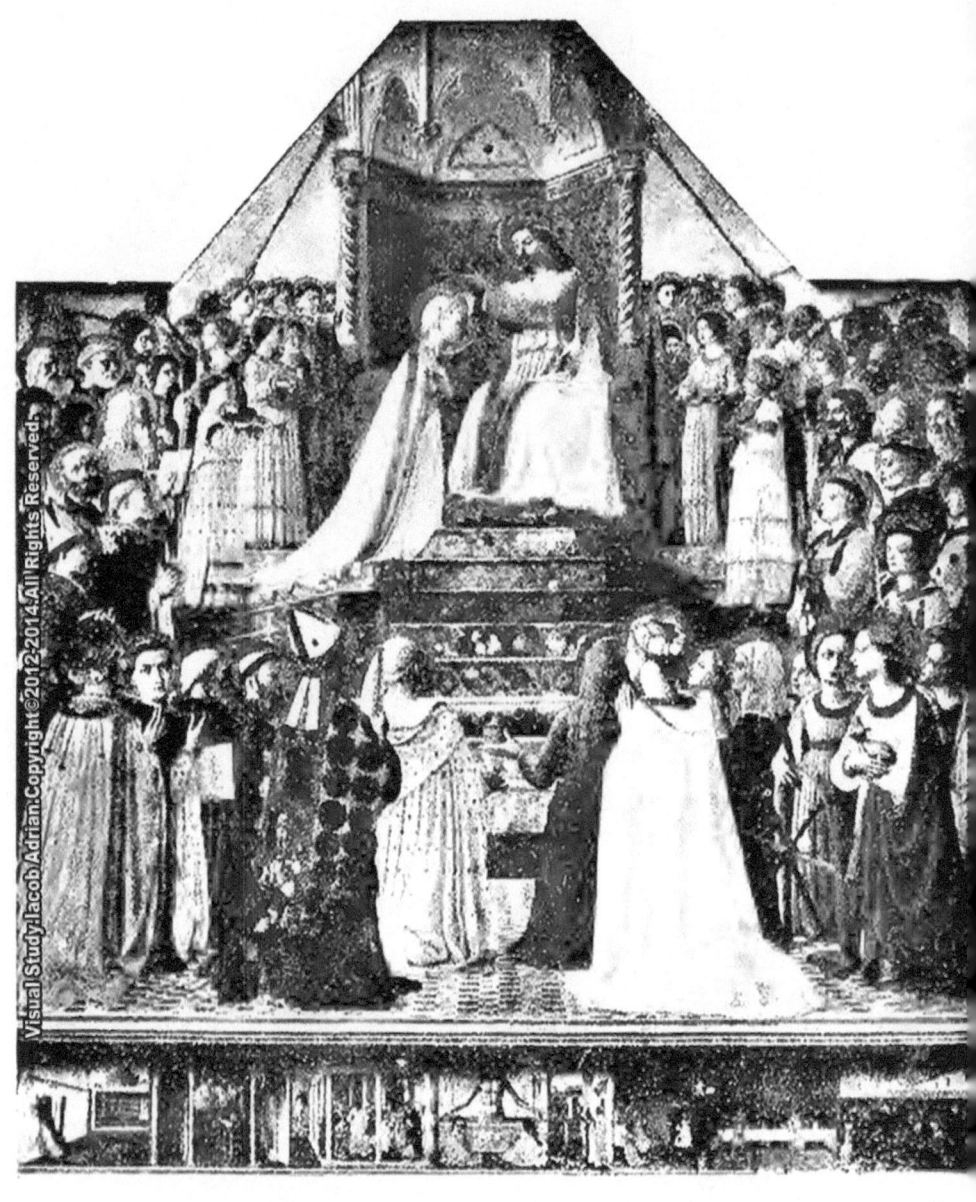

The Coronation of the Virgin
(Louvre, Paris)

La Couronnement de la Vierge
(Louvre, Paris)

Die Krönung Mariä
(Paris, Louvre)

F. Hanfstaengl, Photo.

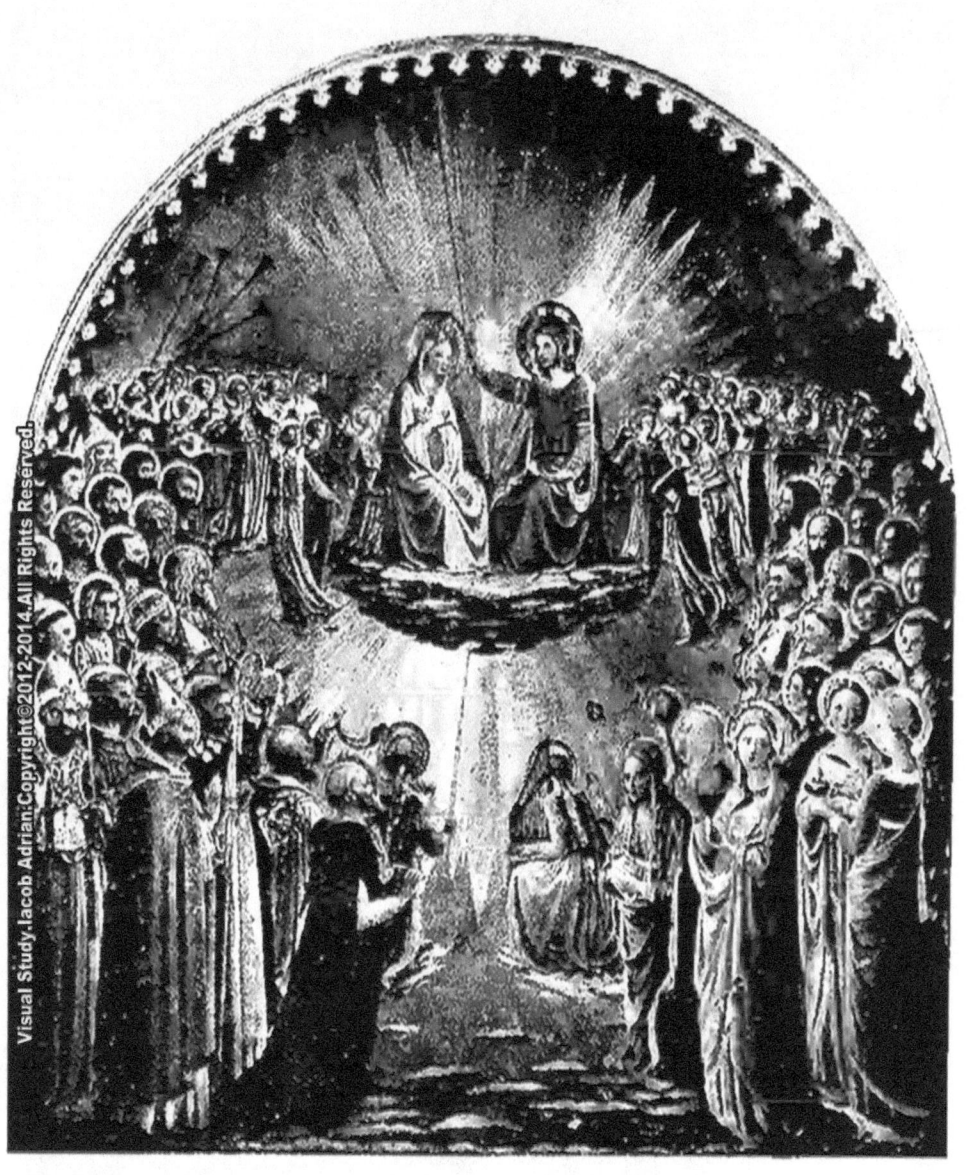

THE CORONATION OF THE VIRGIN
(Uffizi, Florence)

LA COURONNEMENT DE LA VIERGE
(Galerie des Offices, Florence)

DIE KRÖNUNG MARIÄ
(Florenz, Uffizien)

F. Hanfstaengl, Photo.

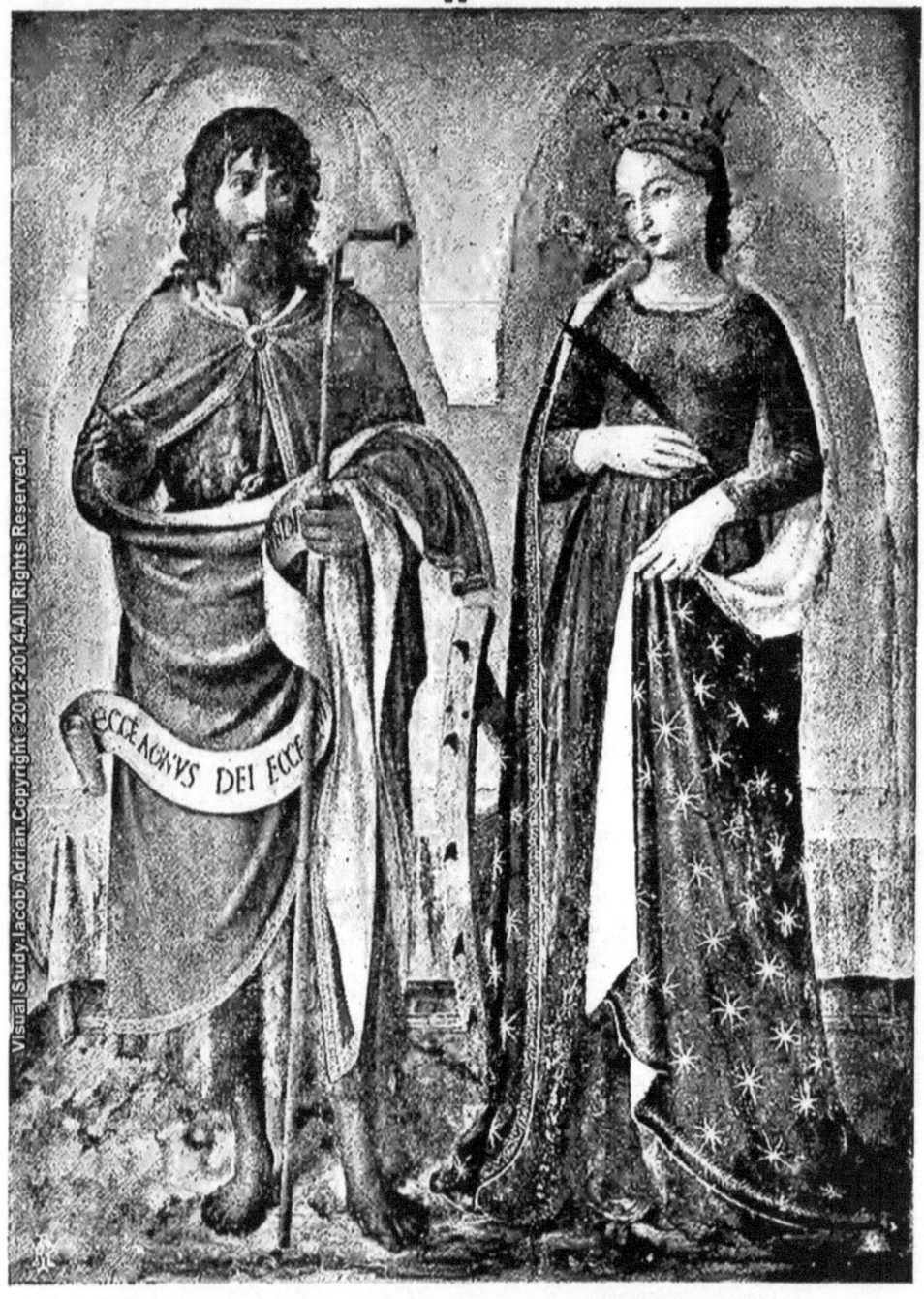

ST. JOHN THE BAPTIST AND ST. CATHERINE
(Pinacotheca, Perugia)
ST JEAN-BAPTISTE ET STE CATHERINE
(Pinacothèque, Pérouse)
JOHANNES DER TÄUFER UND DIE HL. KATHARINA
(Perugia, Pinakothek) Frat. Alinari, Photo.

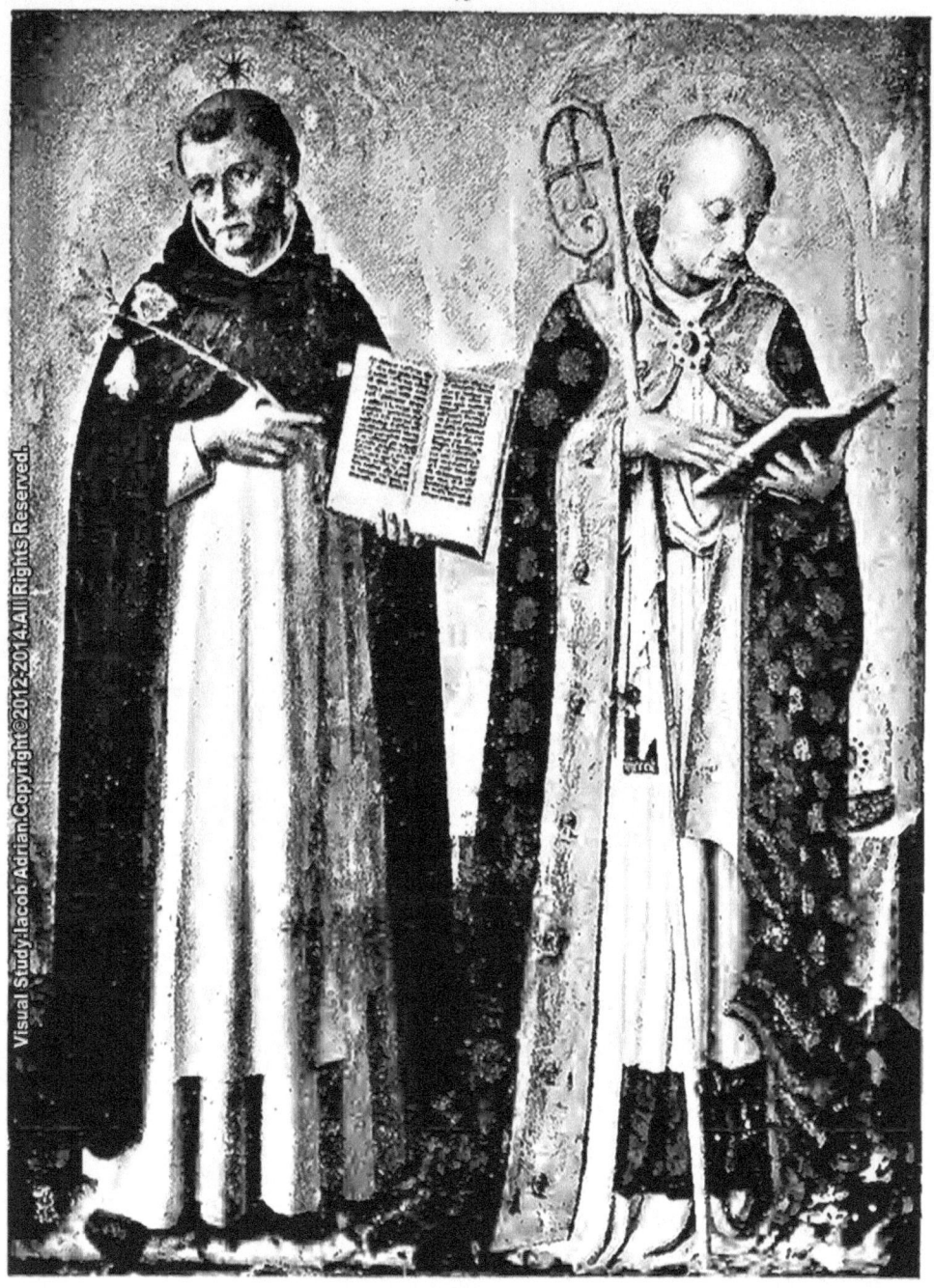

ST. NICHOLAS AND ST. DOMINIC
(Pinacotheca, Perugia)

St Nicolas et St Dominique
(Pinacothèque, Pérouse)

DIE HEILIGEN NIKOLAUS UND DOMINIK
(Perugia, Pinakothek) Frat. Alinari, Photo.

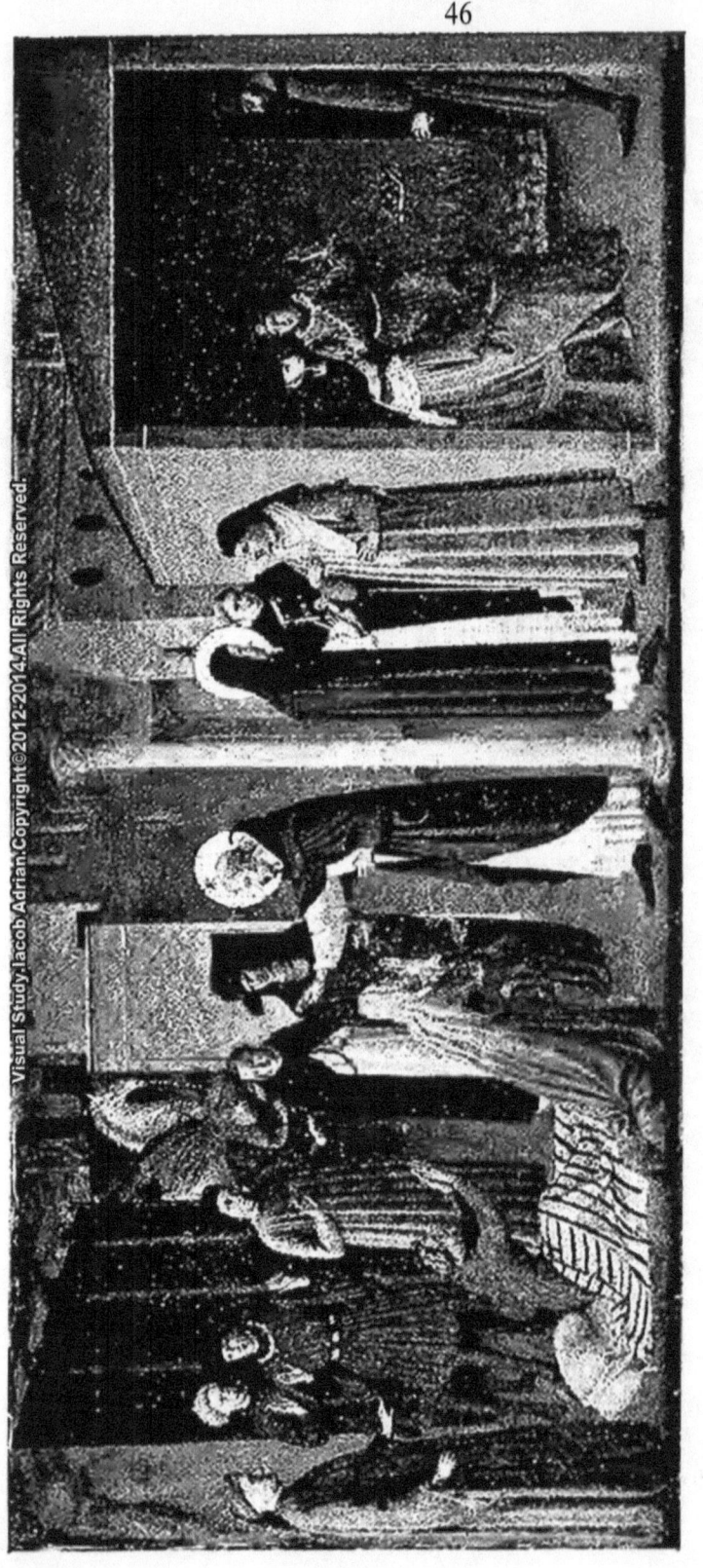

The Life of St. Dominic (I.)
(Church of Jesus, Cortona)

[Predella]

La Vie de St Dominique (I.)
(Église de Jésus, Cortone)

Das Leben des hl. Dominikus (I.)
(Cortona, Jesuskirche)
Frat. Alinari, Photo.

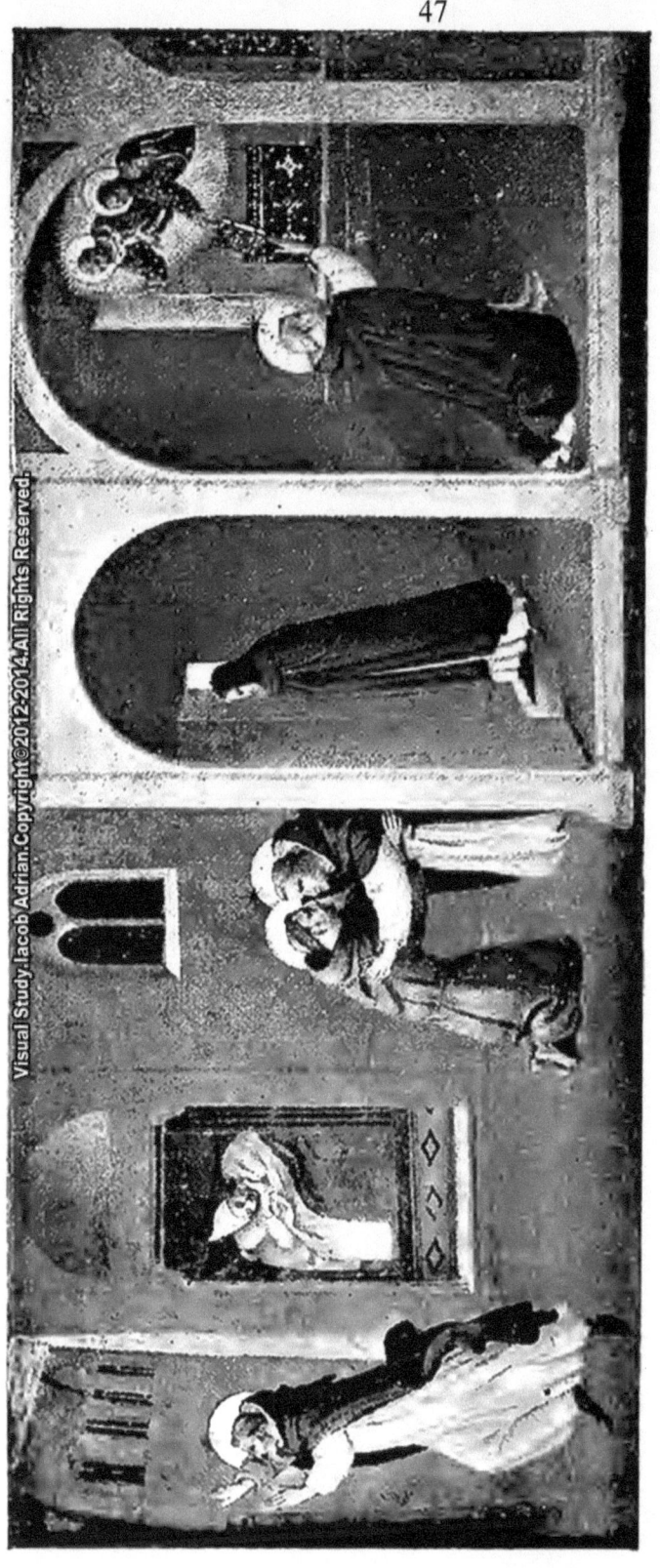

THE LIFE OF ST. DOMINIC (II.) [PREDELLA] LA VIE DE ST DOMINIQUE (II.)
(Church of Jesus, Cortona) (Église de Jésus, Cortone)

DAS LEBEN DES HL. DOMINIKUS (II.)
(Cortona, Jesuskirche)
Frat. Alinari, Photo.

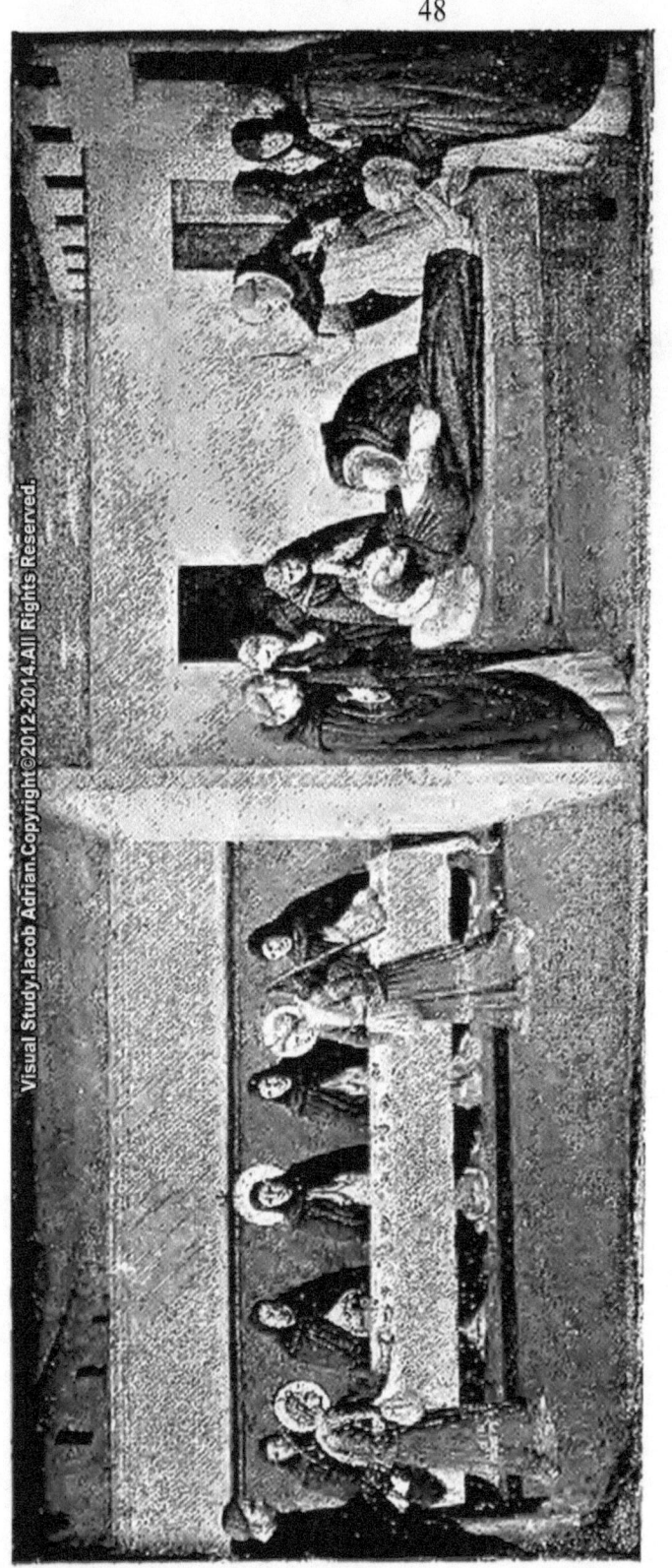

THE LIFE OF ST. DOMINIC (III.) [PREDELLA] LA VIE DE ST DOMINIQUE (III.)
(Church of Jesus, Cortona) (Église de Jésus, Cortone)
DAS LEBEN DES HL. DOMINIKUS (III.)
(Cortona, Jesuskirche)
Frat. Alinari, Photo.

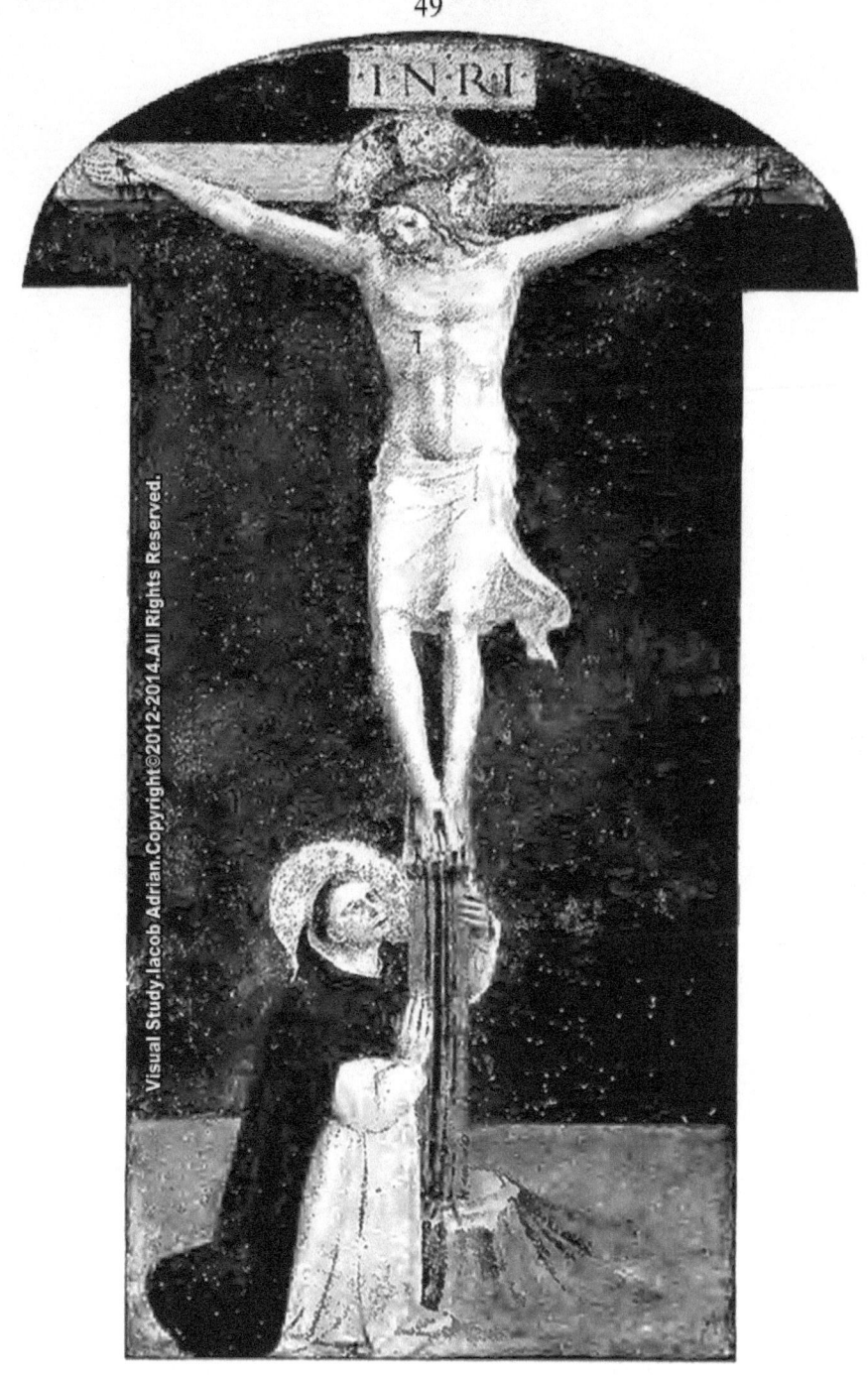

St. Dominic at the Foot of the Cross (Fresco)
(St. Mark's, Florence)

St Dominique au Pied de la Croix (Fresque)
(Église St-Marc, Florence)

St. Dominikus am Fuss des Kreuzes (Freske)
(Florenz, Markuskirche) D. Anderson, Photo.

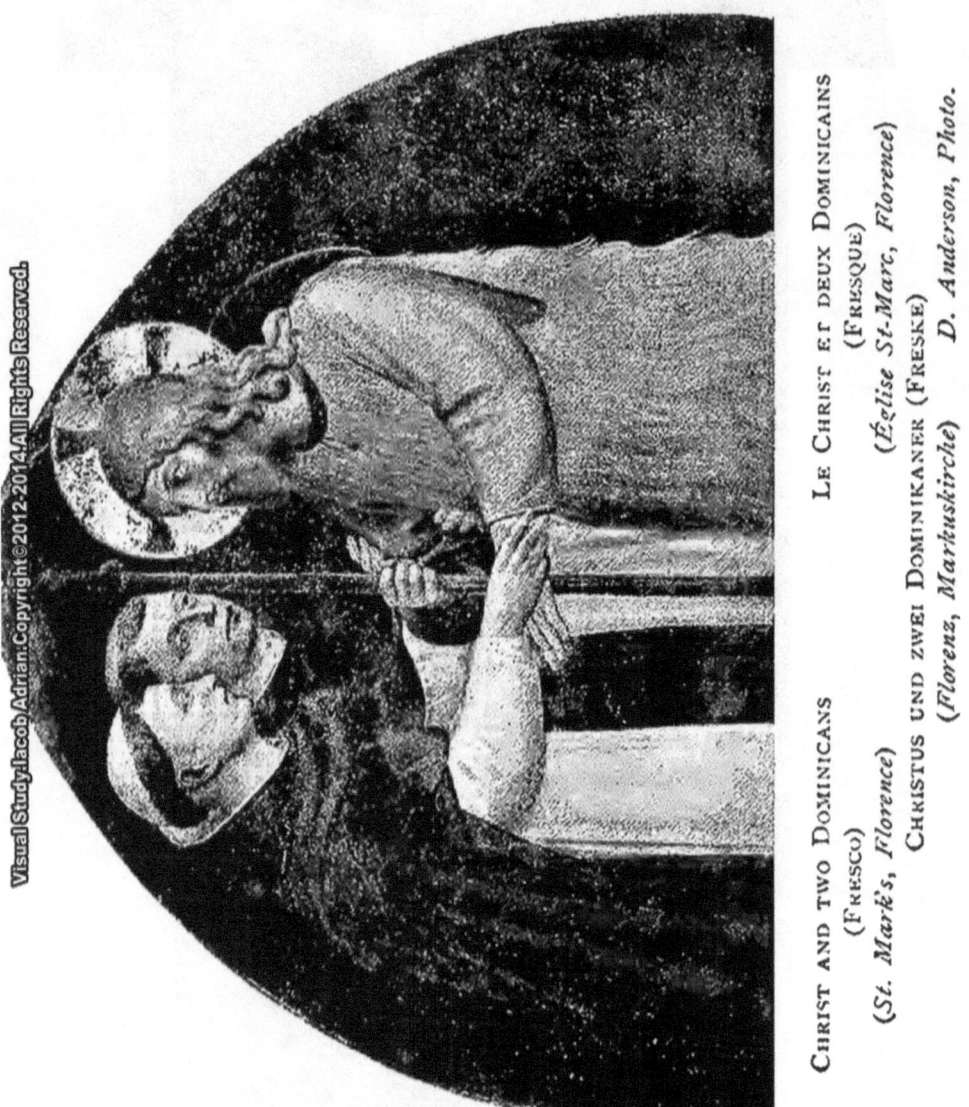

CHRIST AND TWO DOMINICANS
(Fresco)
(St. Mark's, Florence)
CHRISTUS UND ZWEI DOMINIKANER (Freske)
(Florenz, Markuskirche)

LE CHRIST ET DEUX DOMINICAINS
(Fresque)
(Église St-Marc, Florence)
D. Anderson, Photo.

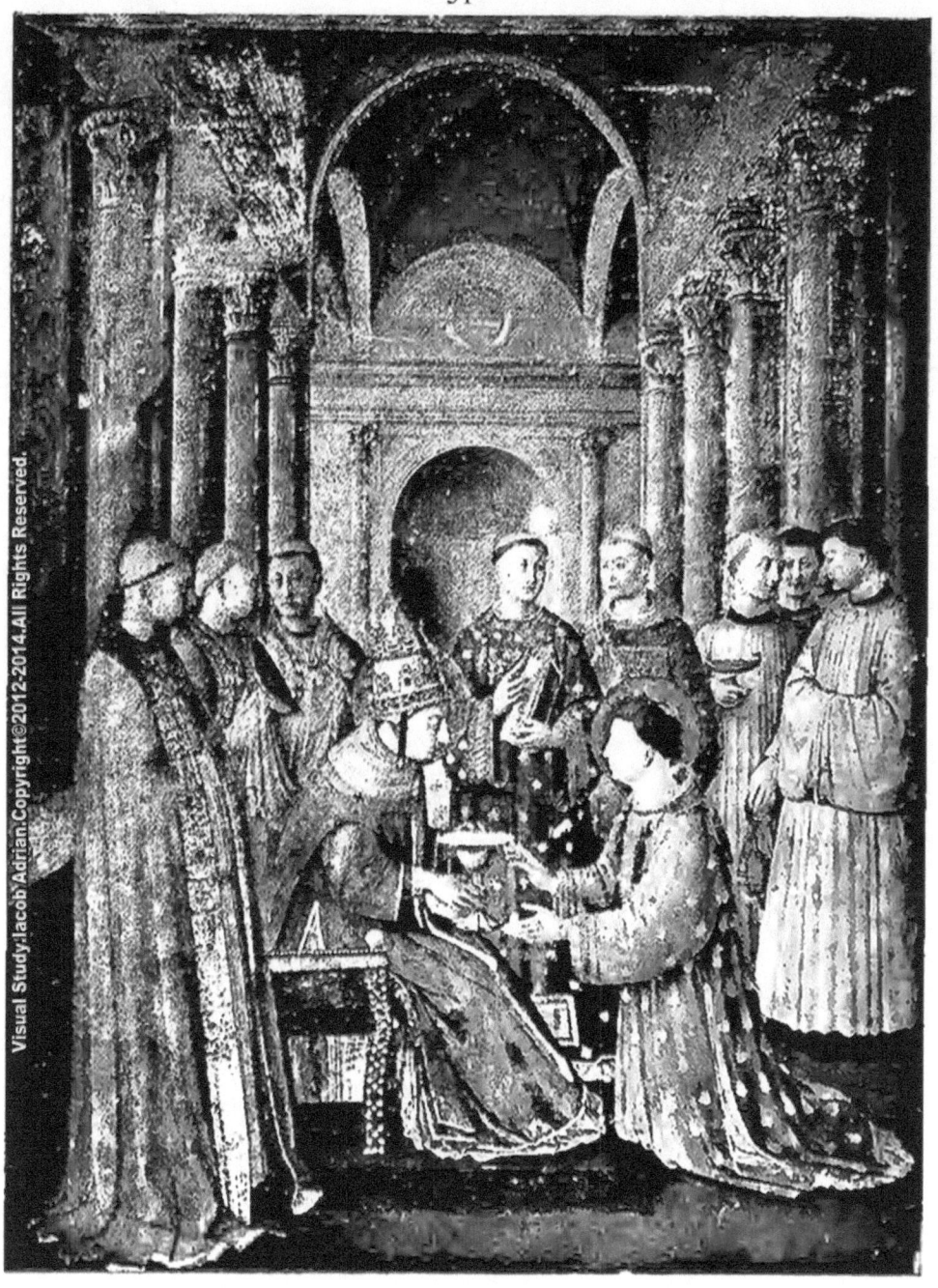

St. Laurence consecrated Deacon (Fresco) (Vatican, Rome)

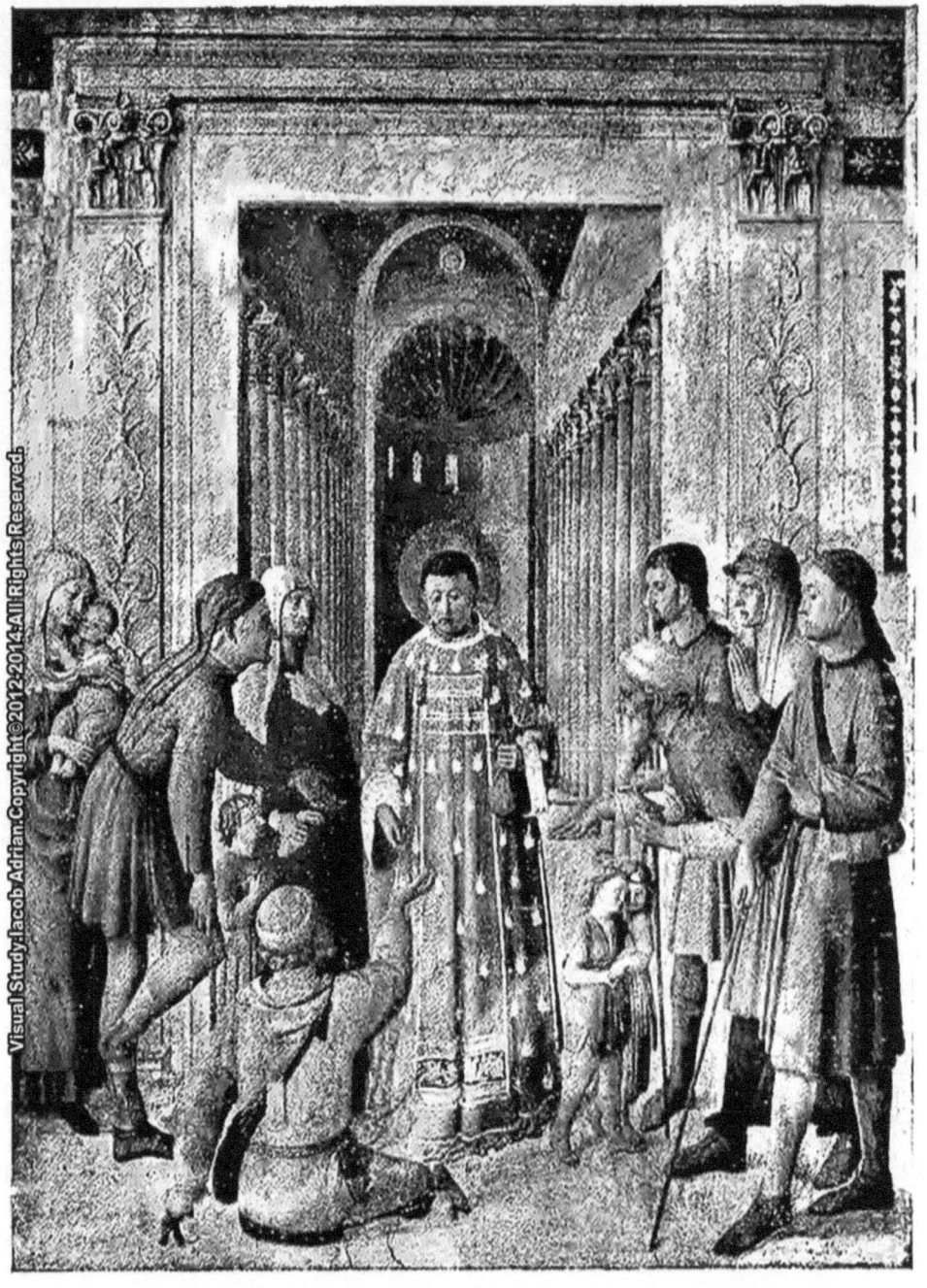

St. Laurence distributing Alms (Fresco)
(Vatican, Rome)
St Laurent distribuant des Aumônes (Fresque)
(Vatican, Rome)
St. Lorenz Almosen verteilend (Freske)
(Rom, Vatikan) D. Anderson, Photo.

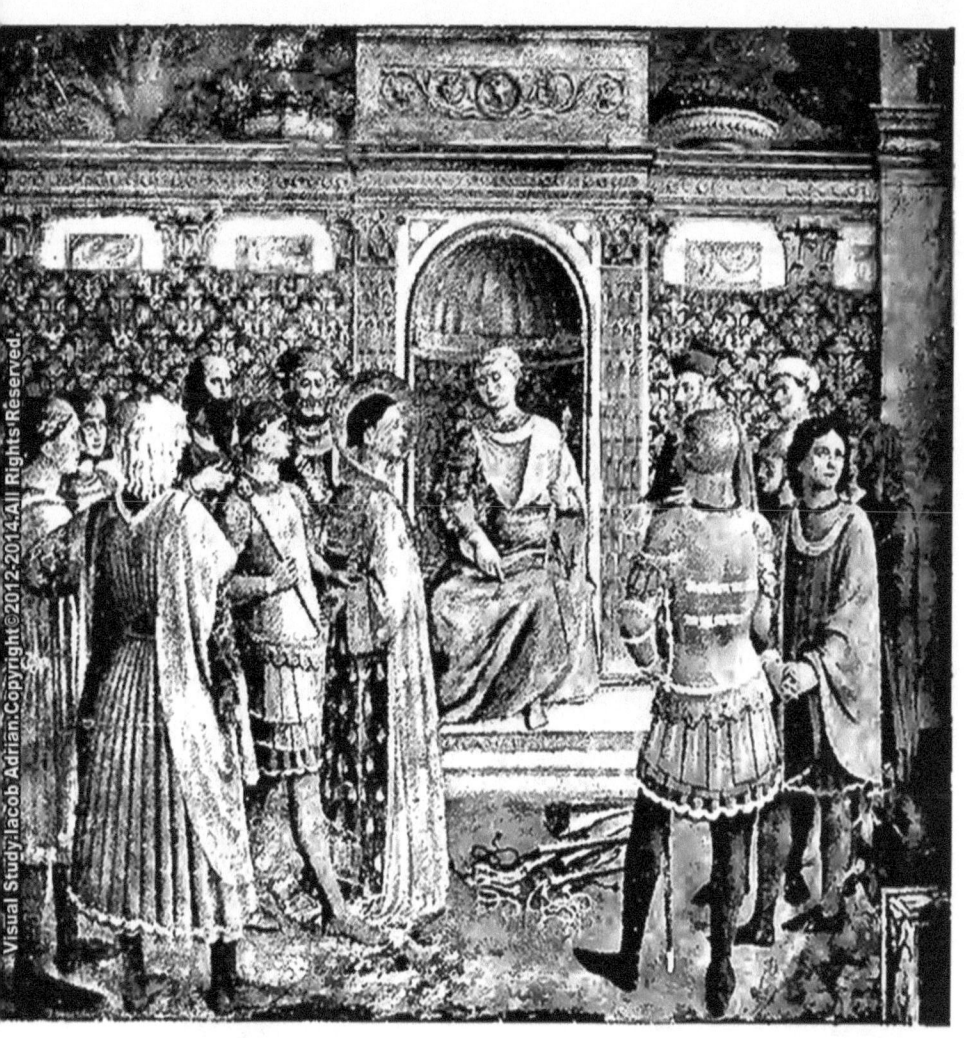

ST. LAURENCE BEFORE THE
EMPEROR (FRESCO)
(*Vatican, Rome*)

ST LAURENT DEVANT
L'EMPEREUR (FRESQUE)
(*Vatican, Rome*)

ST. LORENZ VOR DEM KAISER (FRESKE)
(*Rom, Vatikan*) *D. Anderson, Photo.*

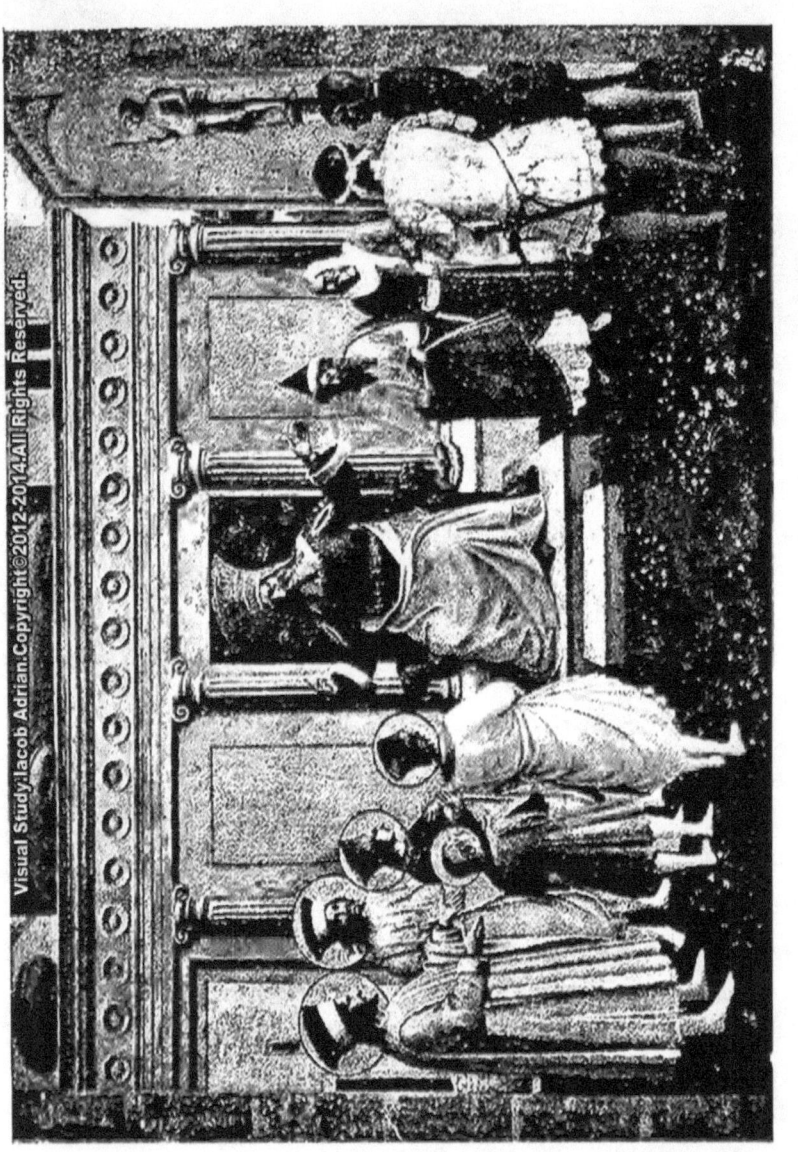

SAINTS COSMO AND DAMIAN [PREDELLA] SAINT CÔME ET SAINT DAMIEN
BEFORE THE JUDGE DEVANT LE JUGE
(Pinacotheca, Munich) (Pinacothèque, Munich)
DIE HEILIGEN COSMAS UND DAMIAN VOR DEM RICHTER
(München, Pinakothek) F. Hanfstaengl Photo.

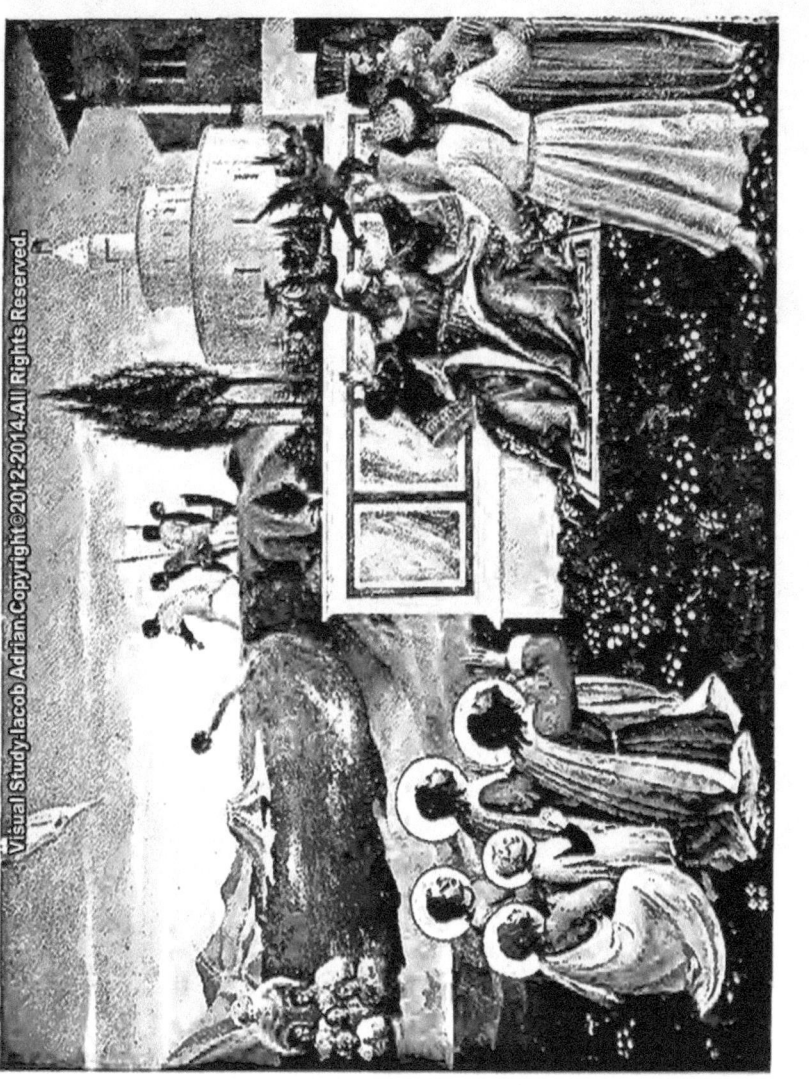

SAINTS COSMO AND DAMIAN [PREDELLA] SAINT CÔME ET SAINT DAMIEN THROWN INTO THE SEA JETÉS A LA MER
(Pinacotheca, Munich) (Pinacothèque, Munich)
DIE HEILIGEN COSMAS UND DAMIAN WERDEN INS MEER GESTÜRZT
(München, Pinakothek) F. Hanfstaengl, Photo.

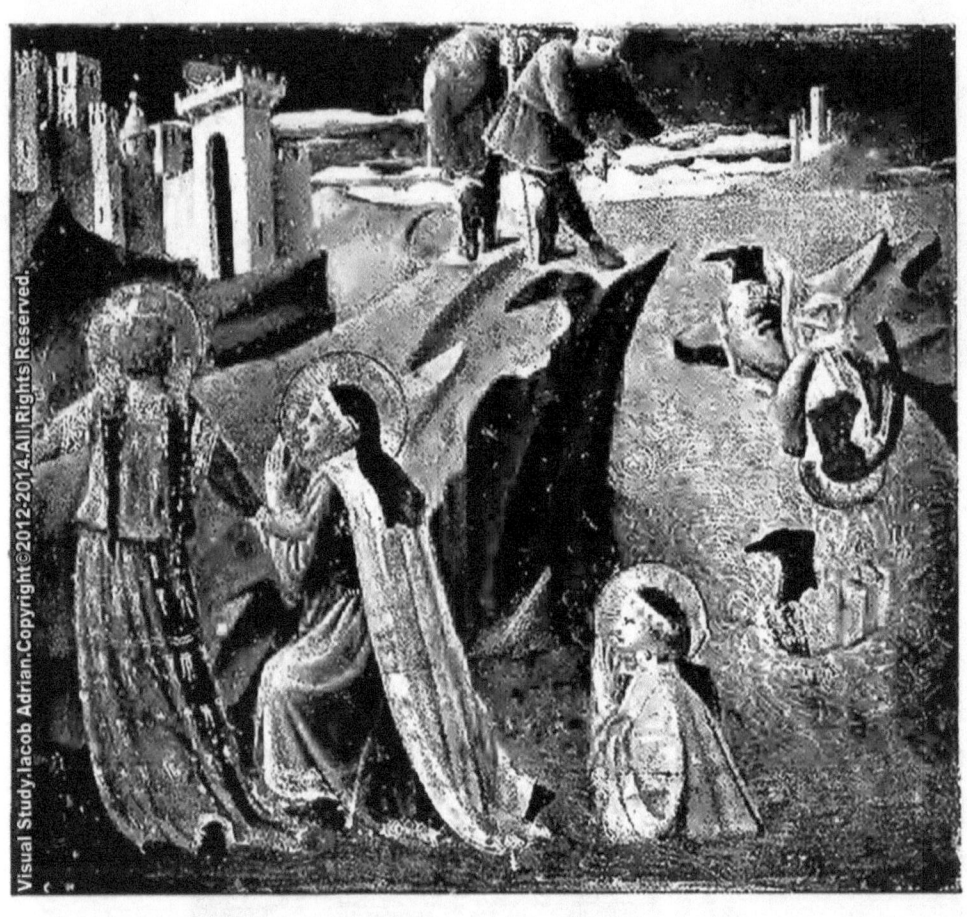

SAINTS COSMO AND DAMIAN THROWN INTO THE SEA
(*Academy, Florence*)
SAINT CÔME ET SAINT DAMIEN JETÉS A LA MER
(*Académie, Florence*)
DIE HEILIGEN COSMAS UND DAMIAN WERDEN INS MEER GESTÜRZT
(*Florenz, Akademie*)
D. Anderson, Photo.

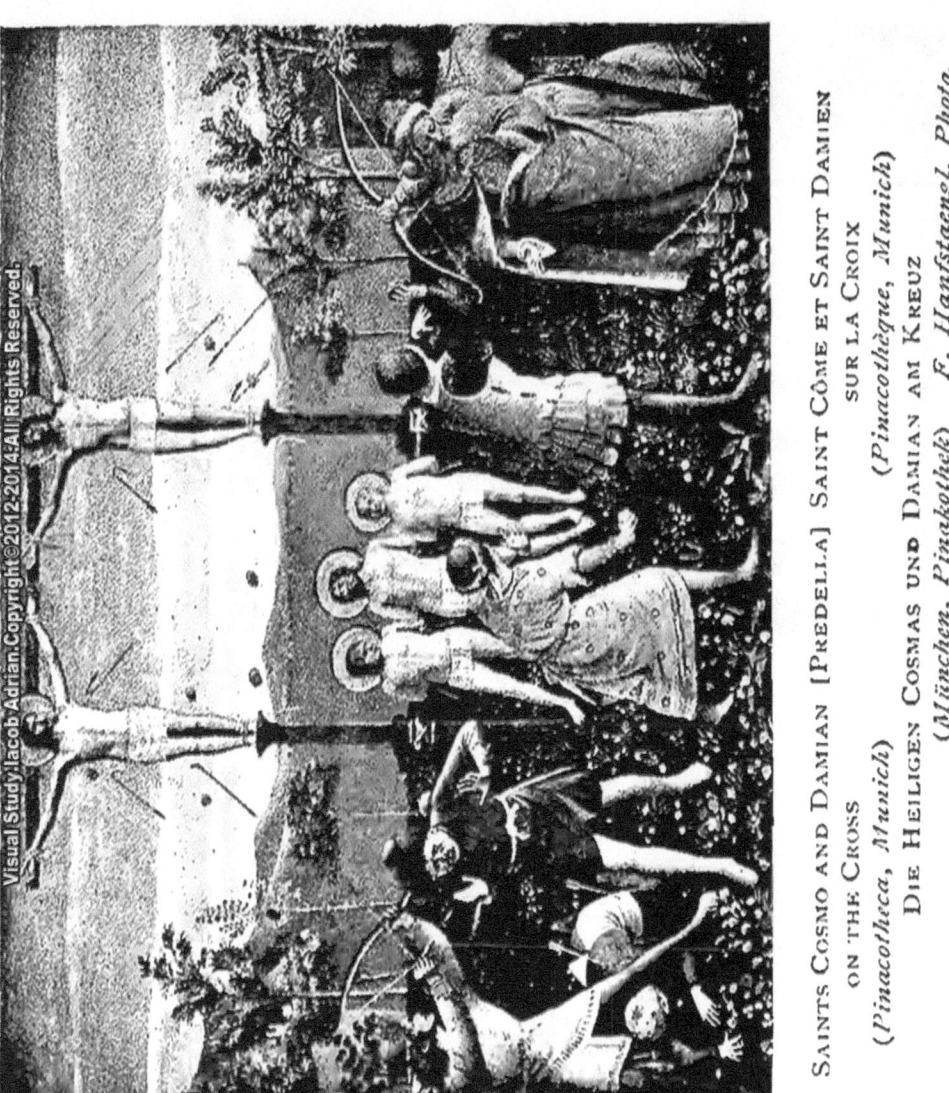

SAINTS COSMO AND DAMIAN [PREDELLA] SAINT CÔME ET SAINT DAMIEN
ON THE CROSS SUR LA CROIX
(*Pinacotheca, Munich*) (*Pinacothèque, Munich*)
DIE HEILIGEN COSMAS UND DAMIAN AM KREUZ
(*München, Pinakothek*) *F. Hanfstaengl, Photo.*

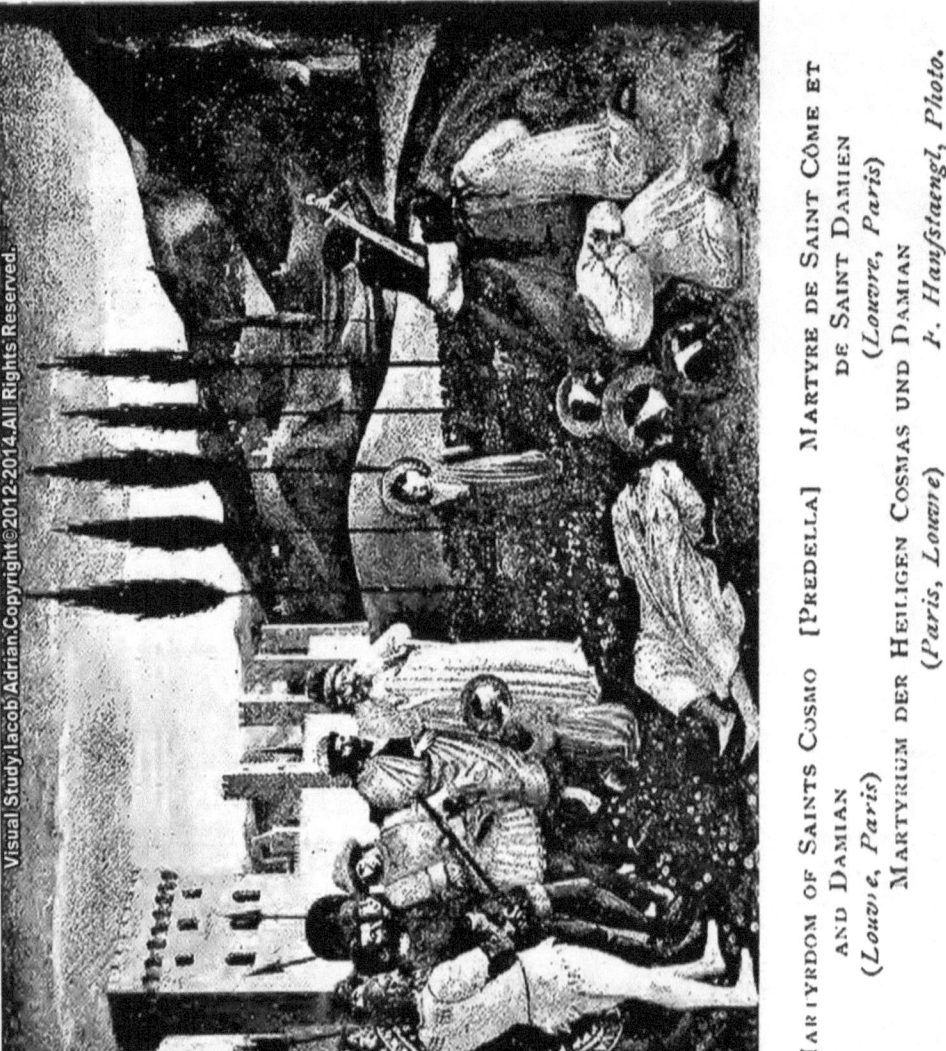

MARTYRDOM OF SAINTS COSMO [PREDELLA] MARTYRE DE SAINT CÔME ET
AND DAMIAN DE SAINT DAMIEN
(Louvre, Paris) (Louvre, Paris)
MARTYRIUM DER HEILIGEN COSMAS UND DAMIAN
(Paris, Louvre) F. Hanfstaengl, Photo.

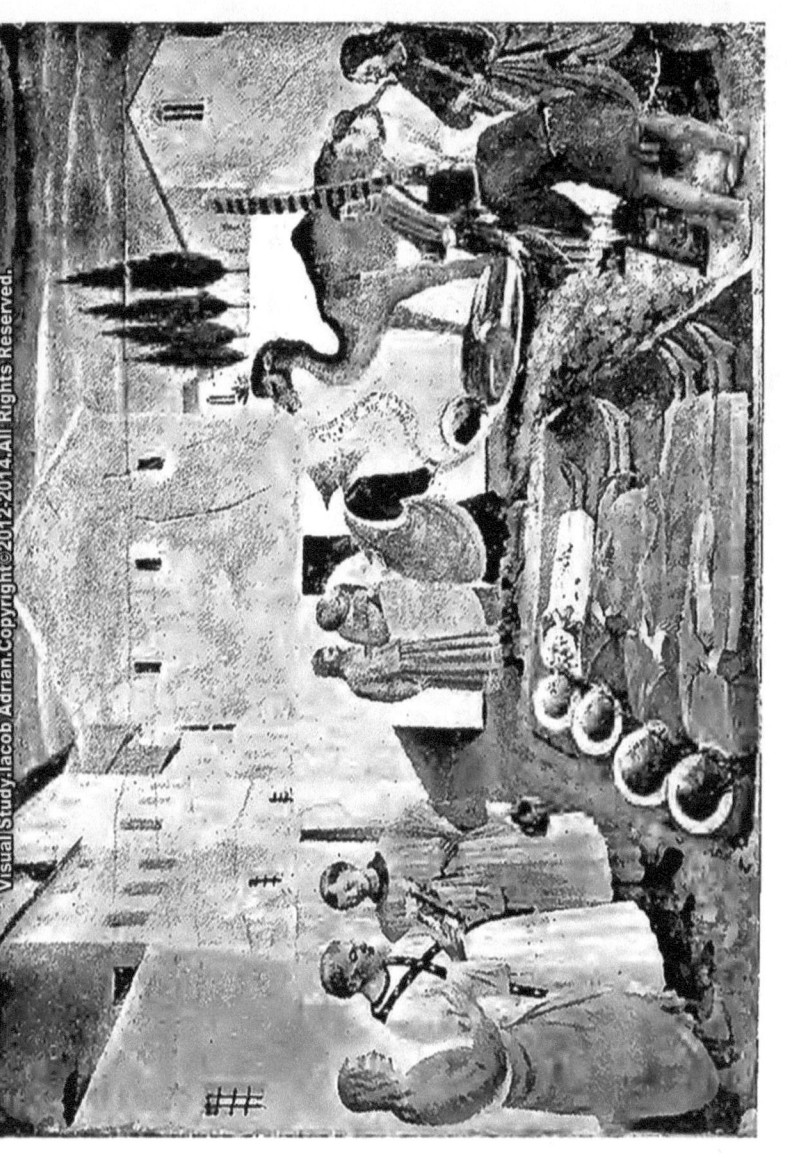

Burial of Saints Cosmo [Predella] Inhumation de Saint Côme
and Damian et de Saint Damien
(*Academy, Florence*) (*Académie, Florence*)
Grablegung der Heiligen Cosmas und Damian
(*Florenz, Akademie*) *D. Anderson, Photo*

Bibliographic sources :

The masterpieces of Fra Angelico (1387-1455) (1908)

Author:
Angelico, fra, ca. 1400-1455;
Cavagna Sangiuliani di Gualdana, Antonio, conte, 1843-1913, former owner. IU-R

Publisher: London [etc.] : Gowan's & Gray, Ltd.

This documentary study use,
combined in various proportions,
elements from the following categories,
forms and subsets :
- fair use
- documentary
- documentary photography
- feature
- journalism
- arts journalism
- visual journalism
- photojournalism
- celebrity photography
in order to :
- employ material as the object of cultural critique ,
- quote to illustrate an argument or point ,
- use material in historical sequence,
providing independent opinion,
using photos, press articles, advertisements,
opinions of fans etc. ...

Copyright©2012-2014 Iacob Adrian
All Rights Reserved.

www.ingramcontent.com/pod-product-compliance
Lightning Source LLC
Chambersburg PA
CBHW021022180526
45163CB00005B/2066